POSTCARD HISTORY SERIES

Times Square and 42nd Street

IN VINTAGE POSTCARDS

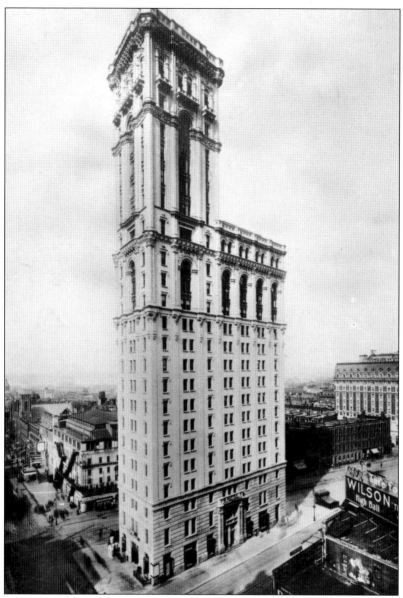

The Times Tower, designed by Cyrus L.W. Eidlitz and Andrew C. MacKenzie and completed in 1904, was built on the triangle formed on the north side of Forty-second Street by the intersection of Broadway (right) and Seventh Avenue. This site had been occupied for only three years by the Pabst Hotel (p. 14) and was the one chosen by New York Times owner Adolph S. Ochs in response to a long-evolving trend for New York to "move" uptown. He relocated the newspaper from its downtown Park Row locale in the midst of a journalistic gathering known as "Newspaper Row." The Longacre Square neighborhood, which was then beginning to attract theaters but was still dominated by carriage and wagon builders, was renamed for the newspaper in 1904. By virtue of the rapid development propelled by the new structure, the Times Tower is one of the most important buildings ever erected in New York. The *c.* 1908 photographic card shows the Astor Hotel (p. 22) at the right, the original Rialto Theater at the left, and the barely visible dome of Holy Cross Church (p. 81) in the left background.

POSTCARD HISTORY SERIES

Times Square and 42nd Street

IN VINTAGE POSTCARDS

Randall Gabrielan

ARCADIA
PUBLISHING

Published by Arcadia Publishing
Charleston, South Carolina

Printed in the United States of America

Library of Congress Catalog Card Number: 00102559

For all general information contact Arcadia Publishing at:
Telephone 843-853-2070
Fax 843-853-0044
E-mail sales@arcadiapublishing.com
For customer service and orders:
Toll-Free 1-888-313-2665

Visit us on the Internet at www.arcadiapublishing.com

I dedicate this book to good and longtime friend Bernard Liling, a trial

lawyer who enjoys the courtroom and revels in any verbal forum. If

the spoken word were performance art, Bernie, pictured with his wife,

Jean, would be New York's longest-running hit. He is a man of sincerity,

compassion, and wit, of a quality infrequently encountered and to be

cherished when found, as do his many admirers.

CONTENTS

Acknowledgments 6

Introduction 7

1. The Crossroads of the World 9

2. West Times Square 51

3. East Times Square 63

4. 42nd Street: The Hudson to Seventh Avenue 75

5. 42nd Street: Broadway to Madison Avenue 85

6. The Grand Central Area 103

7. 42nd Street: Eastern Stem to the United Nations 121

ACKNOWLEDGMENTS

My heartfelt thanks to the numerous contributors whose postcards were instrumental to the completion of this book.

The loan by Karen L. Schnitzspahn of several important original cards (not copies) from one of her primary writing and collecting interests is a rare gesture of friendship and cooperation that deserves special mention.

Gail Greig is a skilled photographer and publisher of fine contemporary postcards. I am thankful for her contribution of these images, which lend a recent glimpse of one of New York's most rapidly changing areas. John Kowalak continues an old tradition of the photographer as postcard publisher through the printing of actual photographs on postcard stock. I thank him for permission to publish his work.

John Rhody, one of the region's most amazing pictorial resources, has supported over 20 of the author's books. Thanks, John. Joan Kay's New York City postcards have a depth and breadth that have repeatedly helped the author. A big thanks, Joan.

Neil Hayne merits special mention, not only for his generosity and trust in lending several images to a writer who was then a stranger, but for his volunteering the acknowledgment that postcard writing helps the entire postcard fraternity. My thanks and appreciation to all the picture lenders, including Saul Bolotsky, Donald W. Burden, Moe Cuocci, William Hansen, Kathleen Ferris Heim, Charles Kleinman, Melvin and Lillian Levinson, Kathleen McGrath, Timothy J. McMahon, and Robert Pellegrini. My thanks, too, to those who answered questions and provided information, including Edward Epstein, an enthusiastic collector who calls himself a "Times Squarologist."

INTRODUCTION

Times Square is the intersection of two major New York thoroughfares. Actually, it is not even a square, but Times Square is recognized as New York's village green. It is the heart of a district that is the core of American popular culture and veritably the crossroads of the world. Times Square emerged from a dismal background as home to a local wagon and carriage industry to be propelled into prominence by a signal event, the erection of the Times Tower in 1904. The choice of site, however, was part of a New York development process of over a century's duration, the seeking of expansion room by a movement uptown.

Forty-second Street is America's main road. Although once considered the northern boundary of commercial New York, the street evolved through location at Times Square and the construction of New York's first great transportation terminal to a major business center. This main stem also developed major residential and hospitality components and emerged at mid-century as a home for international diplomacy.

The transformation of Times Square and the development of 42nd Street are told through the postcard, a communications medium whose rise parallels that of the two areas and one that became an international collecting mania in the early decades of the 20th century. A brief history of the postcard, helpful for appreciating this volume, is presented in capsule summaries of recognized postcard periods:

The Private Mailing Card Era: Postcard use began as a practical matter after the Private Mailing Card Act of 1898, which effectively standardized postcard appearance. Examples, which are not plentiful for New York, are typically imprinted on the back, or address side, with the slogan "Private Mailing Card – Authorized by Act of Congress May 19, 1898." They are rare in the Times Square-42nd Street areas, as there was little of interest to postcard publishers then.

The Postcard Era: Foreign publishers dominated the 1905–1915 period, especially German manufacturers, whose lithography process produced most of the better cards. In addition, photographers printed actual photographs on postcard-size printing paper, typically with the words "Post Card" printed on the back. This period is divided by legislation effective March 1, 1907, which permitted the writing of messages on the back, which had theretofore been reserved for the address. The cards' distinguishing mark is a vertical line in the middle of the address side, dividing the era into "undivided" and "divided back" periods. High protective

tariffs that began in 1909 (which steered the market to inferior American-made cards), the waning of interest that follows any overheated collecting mania, and the onset of World War I brought the period to a close. The era is characterized by publishers with series of well-printed cards, including Rotograph, Illustrated Post Card Company, and Detroit Publishing Company, among others. Some publishers are mentioned in the captions as a matter of interest. The photographers who became postcard publishers by printing pictures on postcard stock produced images that were often tantamount to the news coverage of the day.

The White Border Era: This period, generally defined as 1915 to 1930, with overlaps known, is characterized by its often dismal, poorly printed cards, surrounded by a narrow border of white space on all sides. Its inferior graphics represent the low point of postcard production. The period is redeemed by the realization that important places built in this period are often known only on white border cards, including some major New York City office buildings and hotels. The large New York market was, however, able to produce more photographic cards in this period than most other places.

The Linen Era: A new printing process prevailed c. 1930 to 1950, one that permitted bright colors on an absorbent, rough-surfaced stock that had a look and feel characteristic of linen. A lack of clarity lessened their collector appeal, but interest in linens has risen recently with their aging and an appreciation of their outlandish colors, as well as the travel and advertising topics popular in their era. New York City scenic linens are often of poor quality. However, the linen era was outstanding in the city for restaurant cards.

Chromes and the Modern Era: Printed color cards, often with the clarity of photographs, were introduced nationally c. 1940. New York examples contribute significantly to the history of the past half century. Their size varies from the standard 3.5 by 5.5 inches to the current Continental format, the approximate 4.25- by 5.75-inch size long popular in Europe. Photographic postcards were also issued past 1915; at times few hints exist for dating them.

Various other types and processes do not fit the widely accepted postcard categories. They include monochrome examples of various printing methods and quality and the modern photographic card. Although principally a history of New York, the book's regular reference to postcard publishers addresses the history of the medium, as well.

Times Square had a meteoric rise in the first quarter of the 20th century, a decline that began with a post-World War II fraying at the edges, which led to a precipitous fall c. 1960. New Yorkers shunned the area, perhaps emerging there only for the theater, but many stayed away altogether as sin and vice took a predominating, visible, and palpable presence. Plans for remaking Times Square also rose and fell, seemingly for a quarter of a century. Occasional new construction offered hope. Several projects dating from c. 1990 jelled Times Square's renascence, including removal of its sordid movie houses, key theater restoration projects, and the erection of major office towers. Today, construction is ongoing, and a recently erected sign on the area's key cross street proclaims "New Forty-second Street."

An American Broadcasting Company millennium time capsule sealed at the southeast corner of Broadway and 42nd Street is inscribed with a quotation from Lord Byron: "The best of prophets of the future is the past." The hope and optimism prevalent at Times Square in 2000 leads one to expect its future will be guided by the selective bright spots in Times Square's fascinating past.

The book is divided into chapters in order to reduce a vast, interconnected subject into manageable parts. An occasional discrepancy in that plan may have occurred due to constraints in the organization process. Any confusion was not planned.

There appear to be no consistently reliable sources for ascertaining the heights of buildings, particularly expressed in number of stories, or the number of rooms in hotels. Varying attributions abound; exaggerations exist, probably a result of promotional excess. The author attempted to use the best evidence available and regrets any shortcomings. He welcomes comments and suggestions at 71 Fish Hawk Drive, Middletown, N.J. 07748, (732) 671-2645.

One

THE CROSSROADS
OF THE WORLD

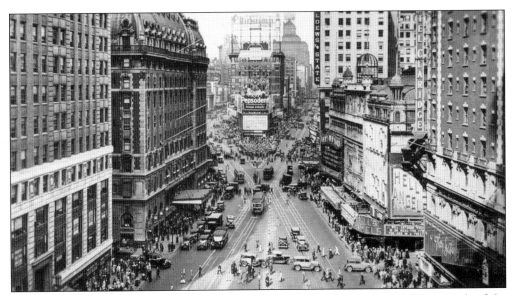

Times Square, the earth's most famed intersection, has earned its nickname "Crossroads of the World" as the vibrant center of American popular culture located in the heart of the world's greatest city. It is not even a square, but rather the crossing of two prominent thoroughfares, Broadway and Seventh Avenue. The history of the streets, buildings, and signs depicted in this 1930s photographic card follow in detail in this chapter, the longest in this volume.

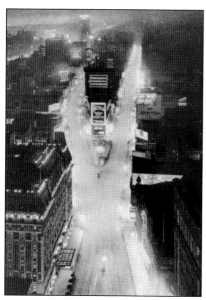

Theater lights had labeled Broadway the "gay white way" long before the district migrated north of 42nd Street. This sobriquet, later and at times alternately used with "great white way," became so closely associated with Times Square and advertising signage that the source and earlier locale of the "way" became obscured in memory. Neither is reflected in the automobile lights of a time exposure photograph reproduced *c.* 1910 on a Detroit Publishing card. Nevertheless, their glow both marks the crossroads intersection and suggests the brightness of this illuminated square that became even brighter toward the end of the 20th century, as electric signage was built into the code requirements for new construction. (Courtesy of Charles Kleinman.)

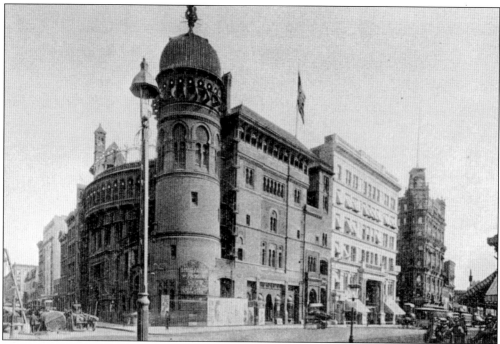

The Moorish-style Casino Theater at the left, designed by Kimball & Wisedell and completed in 1882 at the southeast corner of Broadway and 39th Street, illustrates the northward movement of the theater district. When new, this locale was considered the distant uptown, and the Casino earned the tag of "Arenson's Folly." However, it was the farthest downtown legitimate house when demolished in 1930 and replaced with a high rise for an expanding garment district. Abbey's Theater, designed by Carrere & Hastings and built at the northeast corner of 38th Street in 1893, was known as the Knickerbocker when illustrated *c.* 1905. It, too, met its demise in 1930, also suffering from the joint ills of age and locale. The Hotel Normandie is at the far right.

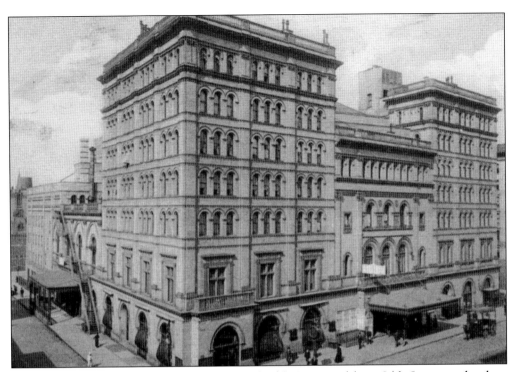

New York's musical life, once centered around 14th Street and later 34th Street, took a leap north when the original Metropolitan Opera House, designed by Josiah Cleveland Cady, was built on the Broadway and Seventh Avenue square block from 39th Street to 40th Street. Completed in 1883, its light-colored cladding and dismal aesthetics gave rise to the fond, informal nickname of "yellow brick brewery." Gutted by fire in 1892 and extensively remodeled in 1902, the hall was richly decorated and an acoustic success, becoming one of the operatic world's most eagerly sought venues. The "Met," suffering from a lack of offstage facilities rather than age or locale, closed in 1966, moving to the present house in Lincoln Center. The building gave way to the wrecker's ball, despite an ardent preservation campaign, and was replaced in 1969 by the steel and glass garment district office tower now on the site. The card is a 1905 Rotograph.

The world's operatic luminaries flocked to the Metropolitan. Frieda Hempel, a brilliant German coloratura soprano born in Leipzig in 1885, entered the conservatory there in 1900 and made her Berlin opera debut in 1905. She debuted at the Met in 1912 as the queen in Meyerbeer's *Les Huguenots*, serving as one of the foremost members of the company from 1912 to 1919. Hempel toured the United States in 1920, playing Jenny Lind in centenary celebrations of the famed Swedish soprano. She was married to William B. Kohn in 1918, divorced in 1926, and resided in New York from 1940 until 1955. Aware that she was fatally ill, Hempel returned to Berlin in 1955, where she died that October. The photographic card appears to be of German issue.

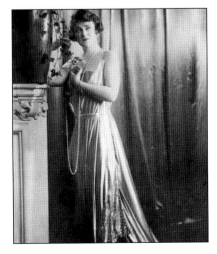

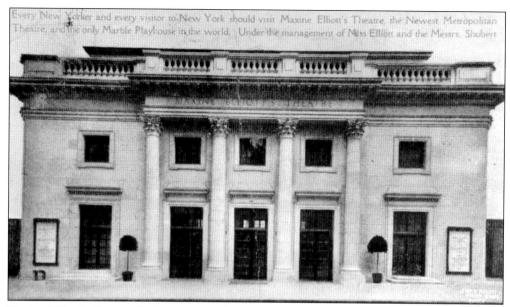

Maxine Elliott's Theater, built in partnership with Schubert interests, was completed in 1908, fulfilling her long-held ambition to operate a theater. The house at 107 West 39th Street, described variously as either 725 or 900 seats, was designed by Chicago architects Marshall & Fox, patterned after Le Petit Trianon at Versailles, and clad in Dorset marble. It was regarded as one of the city's handsomest and most comfortable theaters; its interior was richly decorated, its facilities finely appointed. Maxine Elliott appeared in *The Chaperone* at the December 30, 1908 opening, a time when most new theaters were north of 42nd Street. (Courtesy of Joan Kay.)

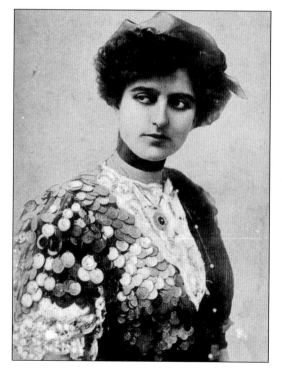

Maxine Elliott, born Jessica Dermot in 1869 at Rockland, Maine, visited New York at age 15 and married George Mc Dermott, probably in 1884. She separated from and eventually divorced him, studied theater with Dion Boucicault, adopted her stage name, and debuted in New York on November 10, 1890, in Henry Arthur Jones's *The Middleman.* Elliott, joined on stage by her sister Gertrude, toured with a number of companies, including that of Nat Goodwin, whom she married in 1898 (and divorced in 1898). Elliott starred on both New York and London stages prior to and following the opening of the theater shown above, in time living in England and on the French Riviera. Maxine Elliott, known as much for her strong will and business savvy as for her statuesque beauty, died childless in 1940. Her image is known on many photographic postcards. (Collection of Karen L. Schnitzspahn.)

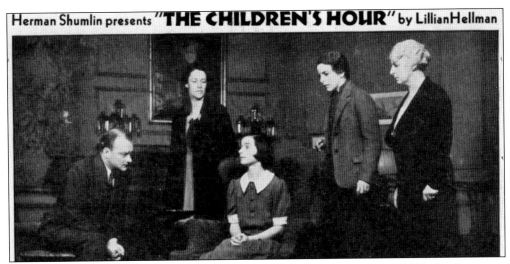

Maxine Elliott's Theater continued to thrive after her last appearance in 1920, hosting many hits. *The Children's Hour* broke the house record in 1936 with 691 performances. The theater was later used as a radio and television studio, last by CBS, which closed there in 1959 after the property had been sold to developers. The building was razed in 1960 and replaced by an office building for the garment industry.

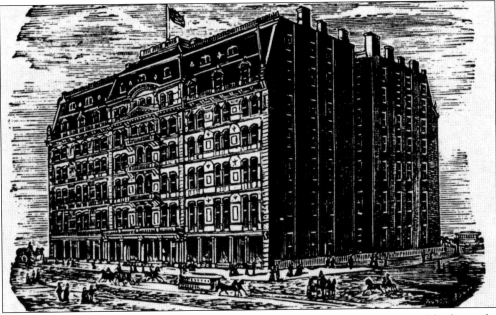

The Second Empire-style Rossmore Hotel was designed by John B. Snook and built on the west side of Broadway between 41st and 42nd Streets from 1872 to 1875. Although its siting was influenced by the new, nearby Grand Central Station, the owners advertised in the 1880 *Phillips Elite Directory*, the source of this image, that their uptown locale was only 20 minutes from Wall Street by elevated railroad. Longacre Square remained a carriage district for another two decades. The Rossmore was later the Saranac. The 11-story, 1915 Brokaw Brothers Building was erected here in 1915. Currently empty, it awaits demolition on one of Times Square's prime development sites.

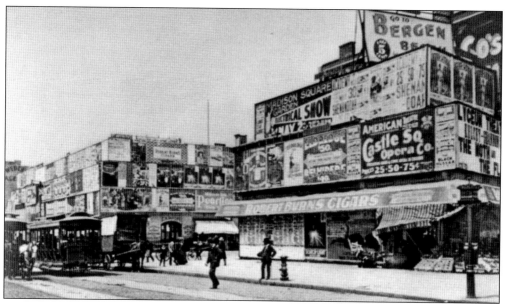

"Forty-second Street marks the end of Broadway as an interesting thoroughfare. Here its distinctive characteristics disappear . . . ," proclaimed E. Idell Zeisloff's *The New Metropolis,* an 1899 historical and pictorial celebration of the newly consolidated city. It went on to describe the area's evolving entertainment and nightlife character, apparently lacking distinctiveness, but one that would soon fade the memories of the theater district then south of 42nd Street. That book is the source of this *c.* 1895 street scene, a site pictured on page 2, a few years later.

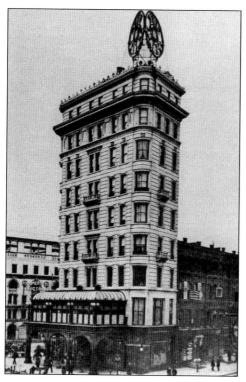

The nine-story limestone-clad Pabst Hotel, designed by Henry Kilburn and Otto Strack and completed in 1899, was built by Charles Thorley, who leased the place, which included a restaurant and bar, to the Pabst Brewing Company. The site was the southern end of the Broadway-Seventh Avenue-42nd Street triangle. A porch extended over 42nd Street from the second-story restaurant, on which the owners added a conservatory in 1900. This sidewalk encroachment became a legal issue with the city, which forced its removal the next year. Following a second constriction, the elimination of a basement rathskeller by construction of the Broadway subway, Thorley sold his lease to Adolph S. Ochs, who was assembling the site for the New York Times. Demolition of the Pabst began in November 1902. Henry Collins Brown published this picture in his *Valentine's Manual* of 1916-1917. This was a historical series that depicted old New York. This depiction included the Pabst less than two decades after it was built, a reminder that change, rather than years, ages an image.

Adolph S. Ochs sought the Longacre Square site as one of the few available for a building that would not have its shape determined by the rectangular streets of Manhattan's grid, one broken above Canal Street only by the irregular course of Broadway. Architects Cyrus L.W. Eidlitz and Andrew C. McKenzie designed a building to fit the plot, one compared when new to the Fuller Building, or Flatiron, at 23rd Street. Although the Times Tower was called a second flatiron building, its 20-foot frontage on 43rd Street gives it a distinctly trapezoidal shape. Construction challenges included erecting a foundation around the right-of-way of the IRT Broadway subway line, which runs through a basement, and building a basement pressroom under the subway. Mounting of exterior cladding began at the sixth floor. The image is part of a Detroit Publishing card that also showed a construction picture of the Flatiron Building.

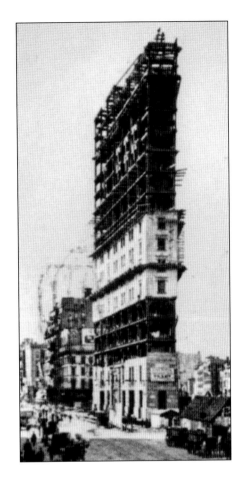

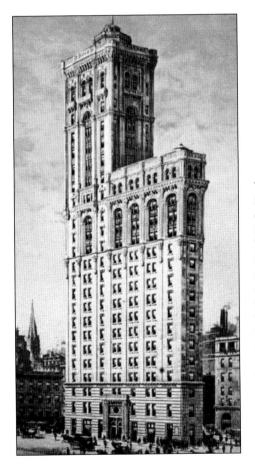

The 362-foot-tall building was the second highest in the city, then exceeded only by the 380 feet of the Park Row Building, located downtown. But the Times claimed a building should be measured from its lowest subbasement floor rather than the curb. If this means were employed, the Times Tower, sunk deep in the earth, would exceed the Park Row Building by 9 feet. The building also had a remarkably high total square footage for its small lot size. The Times had a publication office on the grade floor, presses and mail delivery in basements, and most office functions in floors 13 and above, while floors 2 through 12 were rentable space. Seven offices faced Broadway, including one on the north with a three-sided exposure. The Broadway facade is shown on a card published prior to completion, the image made from a rendering.

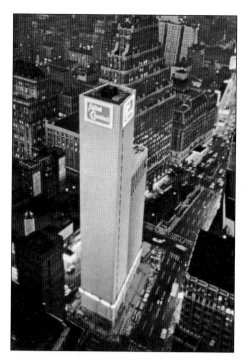

In 1961, the Times sold its tower to Douglas Leigh, who sold it to Allied Chemical in the same decade. The new owner stripped the building to its steel skeleton, while Smith, Smith, Haines, Lundberg & Waehler designed the remodeling, clad in marble. The Allied Chemical Tower included an exhibition hall for contemporary products. This image reflects the structure today, although the building above grade has been emptied and much of its skin is covered by advertising signs. The Times, Paramount, and Astor buildings appear at the top of the tower level, from left to right. At the bottom right is the Long Acre Building, erected in 1912 at the northeast corner of Broadway and 42nd Street and demolished for construction of the Condé Nast Building.

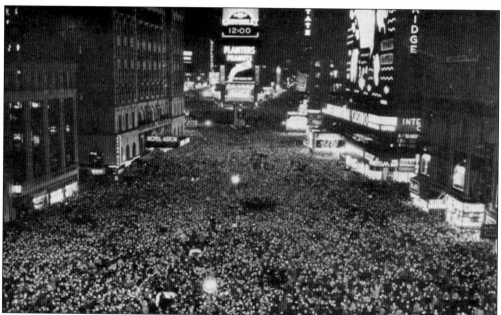

The New York Times sponsored the first Times Square New Year's Eve celebration on December 31, 1904, to draw attention to its new headquarters. The tradition continues to date and was the focal point of America's December 31, 1999 New Year's activity. The early gathering (and probably long-suffering) crowd that year may or may not have seen the millennium turn, but their endurance and enthusiasm were admirable, especially when seen televised into a warm home. The pictured mob, assembled on December 31, 1939, is shown on a card issued by the Hotel Astor to point out that it was the only one with an entrance *directly* on Times Square.

Times Square has long been home to temporary structures built to promote a cause. They range from the commercial, such as a gigantic cash register (how symbolic for New York) built by a 1939–1940 World's Fair exhibitor, to the patriotic, such as a replica Statue of Liberty during World War II. An early example was Leo Lentelli's 20-foot-high plaster statue erected on a 27-foot pedestal, called *Purity* (also called *Defeat of Slander*), sponsored by the Association of New York and unveiled on October 7, 1909. The figure of the stern-looking woman is seen here in an apparent early (she is missing her tiara of incandescent lights) sculptor's model. The founding principles of the Association of New York included challenging indiscriminate abuse and criticism of New York; in addition, the statue was also to reflect the city's purity and beauty. The symbolism was not immediately recognized, and the statue became the subject of speculation, scorn, and parody. *Purity*, considered a setback for academic sculpture, was taken down in December 1909.

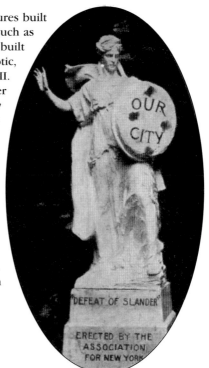

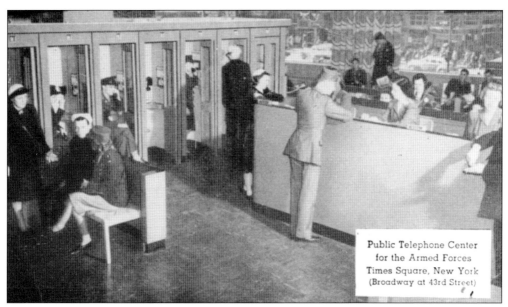

Public Telephone Center for the Armed Forces Times Square, New York (Broadway at 43rd Street)

Times Square nightlife long held an appeal to men in uniform. This Public Telephone Center provided a convenient place to make a call. Notice the once common door-enclosed booth with a seat. Surely there must be an example or two in an old restaurant or other facility, but one should be preserved by a museum as a faded piece of Americana. This card was posted in 1945 by a soldier using a handwritten "free-frank," permitting its mailing without postage. (Courtesy of Joan Kay.)

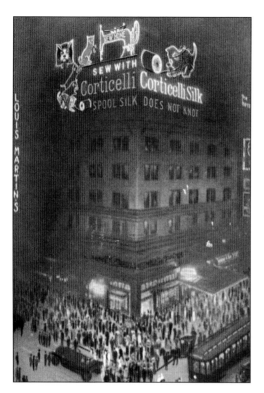

Corticelli Silk Mills of Florence, Massachusetts, which claimed its spool silk was too strong to break and used playful cats in print advertising, placed their felines in action on a moving 100- by 35-foot electric sign that contained nearly 3,300 bulbs. The sewing machine started running and the small kitten played with the spool of silk and then jumped on the sewing table, where it played with the machine's silk. The larger cat played with the spool and became entangled in the red silk, with the spool revolving and the cat's paws and tail moving in a lifelike way. The sign was mounted on the Heidelberg Building (p. 86).

The early major Times Square buildings spanning 44th and 45th Streets are seen c. 1906, with their neighbors. At the left, in front of the Hotel Astor (pp. 22, 23) is the Putnam Building. Shanley's Restaurant (p. 25) expanded into them. The original Rector's Restaurant is at the right, in front of the New York and Criterion Theaters (p. 21). The Studebaker Building in the background, the only pictured building still standing, appears elsewhere several times in backgrounds as the home of numerous signs. The snow has constricted the broad plaza made by the Broadway-Seventh Avenue crossing.

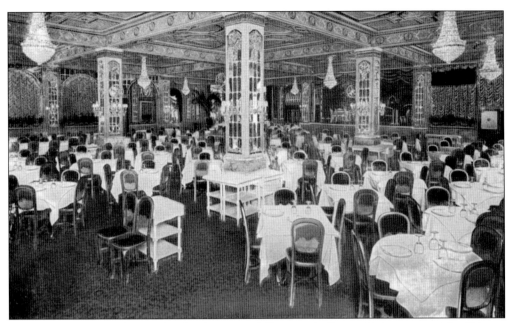

Charles Rector, who honed his food service skills on a Pullman dining car and in Chicago restaurants, including the only eatery at the 1893 Columbian Exposition, came to New York in 1899, when he opened Broadway's most lavish restaurant, between 43rd and 44th Streets. Rector's Restaurant set new standards for food, decor, service, and as a fashionable destination. The founder was assisted by his son George Rector, whose extensive training included fine French sources. The image is the dining room of a later Rector's at 48th Street and Broadway.

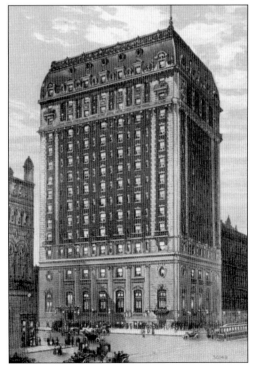

The Hotel Rector was built by the Rectors in 1910–11 on the site of the former restaurant, its design by D.H. Burnham of Chicago a late expression of Second Empire-influenced style. The 16-story, 700-room brick and limestone hotel carried its builders' name for only a few years, being renamed the Claridge by 1914. Rector had suffered financial reverses. Although his restaurant was once at the pinnacle of New York nightlife, it had lost public esteem after a play called *The Girl from Rector's* helped make it plain that it and similar establishments catered to loose and kept women. The restaurant, by then relocated to 48th Street, closed on January 1, 1919. Retail stores in time filled the Broadway side, as 160 West 44th Street became the hotel's main entrance. The hotel stood until it was demolished *c.* 1972 for construction of the 1500 Broadway office tower that is now on the site.

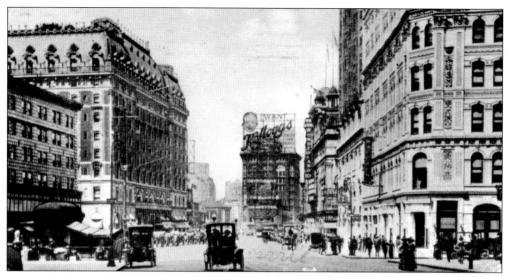

A *c.* 1912 view north from 43rd Street shows the Cadillac (Wallick) (p. 26) at the right and the Rector (Claridge) (p. 19) on 44th Street behind it. Shanley's (p. 25) is at the left, and adjacent to it on the 44th-45th Street block is the Hotel Astor (pp. 22, 23). The Studebaker Building, showing an appealing early Kellogg sign, was long a prominent location for large signs, but the erection of the high-rise Renaissance Hotel in front of it has curtailed its utility as an advertising host. (Courtesy of Joan Kay.)

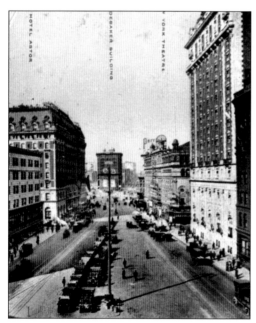
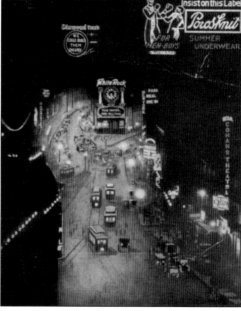

The nine-story Studebaker Building at 1600 Broadway, seen in 1911 on its south, or 48th Street, facade, was built in 1902 on the site of the former Central market. It soon became ornamented by signs and for many years held some of the most important ones. Note the early instance of New York drivers' penchant for parking anywhere. The Porosknit card provides a convenient caption on the front.

20

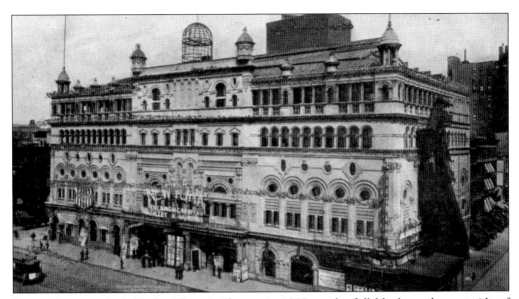

Oscar Hammerstein built the Olympia Theater in 1895 on the full block on the east side of Broadway between 44th and 45th Streets. Designed by John B. McElfatrick, the building was the first significant entertainment construction north of 42nd Street. Business foundered at the massive complex, which was later broken into separate theaters. Pictured *c.* 1910 as the New York and Criterion theaters, the old Olympia was demolished in 1935 and replaced with a smaller movie theater building (p. 36).

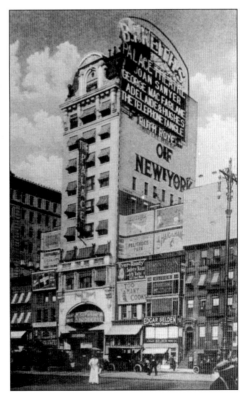

The "Supreme Vaudeville" promised by the sign had a longtime run at the Palace, which was completed in 1913 to a design by Kirchhoff & Rose. Built by Martin Beck, the Palace was the last of the area theaters established for vaudeville and was soon taken over by Edward F. Albee, following questionable transactions. The 1,700-seat theater became a symbol of success. Performers eagerly sought bookings on a stage that could propel them to national exposure. Motion pictures were later shown, often in conjunction with live presentations. The Palace's interior, designated a landmark in 1987, was restored, but the building around it was demolished. However, the hotel built on the site incorporated the old theater interior.

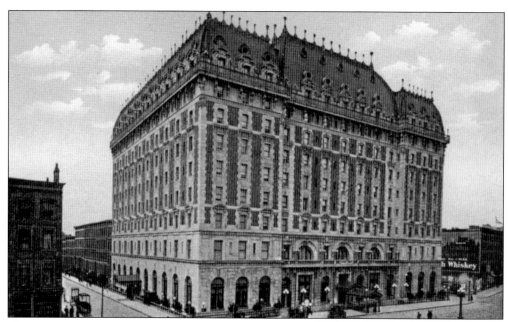

The 11-story Beaux Arts-style Hotel Astor was designed by Clinton & Russell. The hotel was built on the west side of Broadway block between 44th and 45th Streets, on former farmland that had been in the Astor family for about seven decades. The opening of the hotel coincided with and contributed to the transformation of the former Longacre Square's carriage and wagon trade to entertainment. Note the brownstone houses left of the Astor; they were soon replaced by hotel expansion. The balcony at the ninth floor was open to visitors in season. The many lamp stands, there and on the green copper mansard roof, made a bright nighttime silhouette.

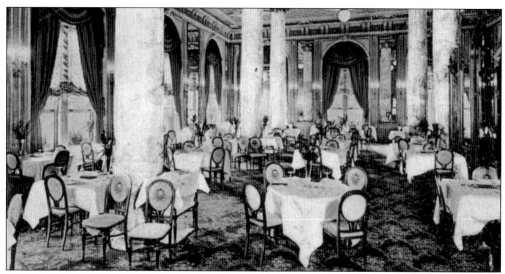

The Astor contained a variety of restaurants and banquet rooms, which changed over the years with fashion. The impact of the richly decorated interiors, such as the Louis XIV Ladies Restaurant, pictured c. 1905, was comparable to the brightness of the Great White Way. The many elaborate entertainment facilities of the new Astor cast it as a rival of the original Waldorf-Astoria at Fifth Avenue and 34th Street.

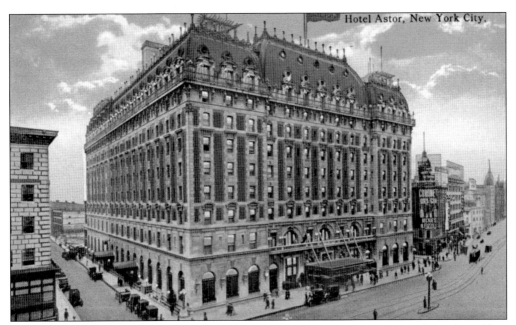

The shading difference at the left depicts six bays added on the west, *c.* 1909, and the cleared lots denote future expansion space. Other changes pictured here *c.* 1912 include a canopy over the front door and the Astor Theater, built in 1906, on the northwest corner of Broadway and 45th Street. The Astor was remodeled from time to time to keep current and profitable. The impact of prohibition dealt a blow in the 1920s, but the venerable Astor endured. Age finally caught up with the grande dame of Times Square hotels in the 1960s; it was demolished in 1967. Taking down the Astor demonstrated the solidity of its construction and proved to be a difficult and costly job for the demolition contractor.

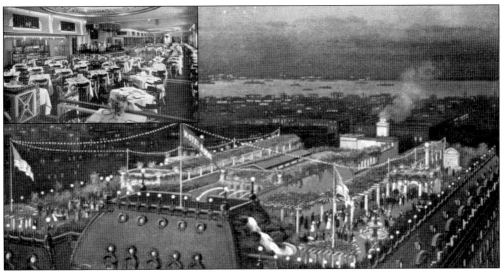

Roof gardens, conceived as a theatrical effort to combat the necessity of closing to avoid stifling summer heat, were adapted for open-air eating. The brilliantly lit Astor, seen *c.* 1905, was one of the most popular. Some gardens were reinvented as enclosed air-conditioned restaurants. As such, the Astor's (inset) offered name bands at dinner and late evening repasts.

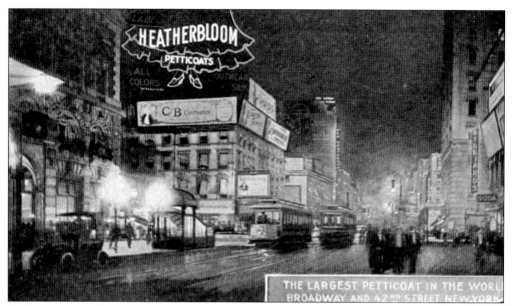

Only a portion of the sign advertised as "the largest petticoat in the world" is seen on this *c.* 1912 view, looking west on 42nd Street. Heatherbloom was mounted on the Heidelberg Building; the Knickerbocker Hotel is at the left. This unmailed example was probably used as a salesman's handout, as a facsimile of the woven silk Heatherbloom label is affixed to its back.

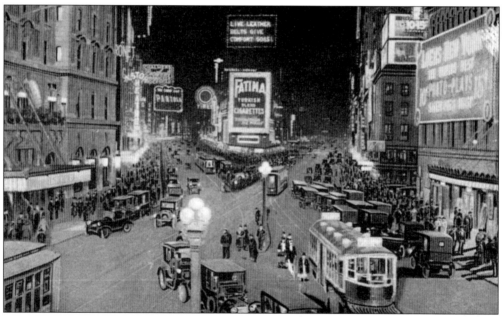

The large Fatima sign on the Studebaker Building is the focal point of this *c.* 1912 Detroit Publishing card, but other signs offer glimpses into faded memory (Chalmers, the underwear rather than the automobile) and future signage (the small Chevrolet symbol was a forerunner of what later emerged in large and long-lasting signs). "Photo-play" is an obvious precursor of "film," but how "live" was a "live leather belt"? The perspective is north from 44th Street with the Astor at the left.

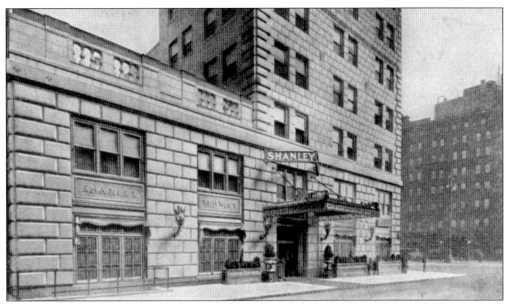

After operating a successful restaurant on 23rd Street, Shanley Brothers opened a restaurant *c.* the 1890s on the east side of Broadway between 42nd and 43rd Streets. They and their kind were known as "lobster palaces," a term reflective of their character and stature, as well as their ability to deliver large crustaceans. Shanley moved *c.* 1908 across the street to the Putnam Building, which ran the block from 43rd to 44th Street, remodeling it as pictured here *c.* 1910. (Courtesy of Saul Bolotsky.)

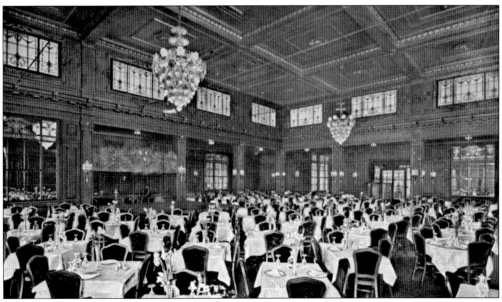

The "lobster palace" was a luxurious eatery that appealed to entertainers, theatergoers and the higher social classes, some of whom found these establishments helpful for assignations. Alcohol was a key ingredient for fueling their operation. Shanley's was closed by prohibition in 1922. The two cards are part of a series of views of the place.

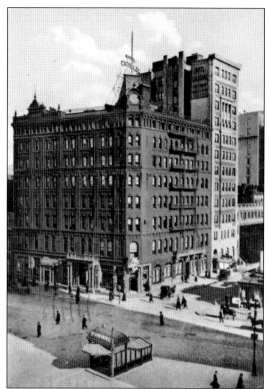

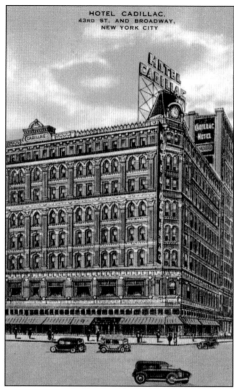

HOTEL CADILLAC.
43RD ST. AND BROADWAY,
NEW YORK CITY

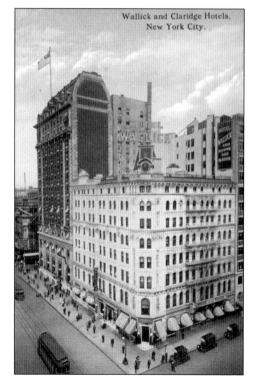

Wallick and Claridge Hotels,
New York City.

The Barrett House was built on the northeast corner of Broadway and 43rd Street *c.* the 1880s. It changed its name to the Cadillac Hotel *c.* 1898. The card on the upper left dates from *c.* 1905. The one on the right, *c.* 1925, depicts changes in signage and storefronts. It appears that the three bays on the north and the upper two stories were later additions.

The Cadillac was known as the Wallick by 1914 and for a few years thereafter, and then it resumed the former name in the 1920s. The view north also shows the Claridge Hotel on the southeast corner of 44th Street, seen on page 19 when new and carrying its original name, the Hotel Rector. The Cadillac survived until *c.* 1940. The 1500 Broadway office tower, built in the early 1970s, now fills the entire block.

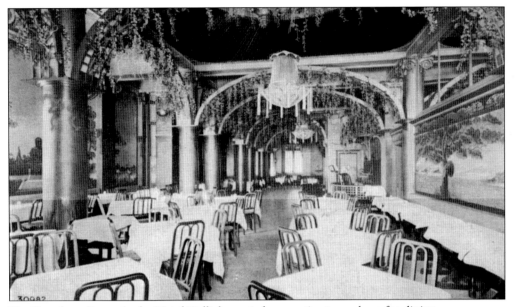

The Kamakura Room in the Hotel Wallick created an exotic atmosphere for dining.

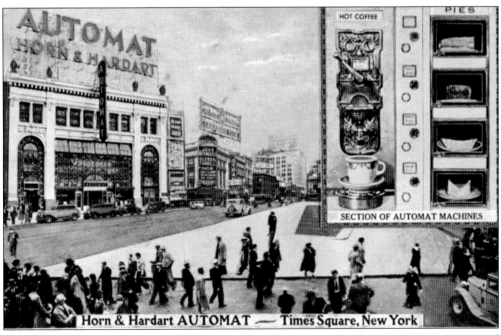

The Automat was a self-service restaurant that originated in Philadelphia but was associated with New York because of the large number of outlets there. The first in the city opened in Times Square at 1557 Broadway on July 2, 1912. The white terra-cotta-clad building with a two-story-high stained-glass window designed by Nicola D'Ascenzo is pictured on a late-1930s Lumitone card. Initially each item of a limited menu cost 5¢ and was procured by dropping a coin in a slot next to the window displaying the desired viand.

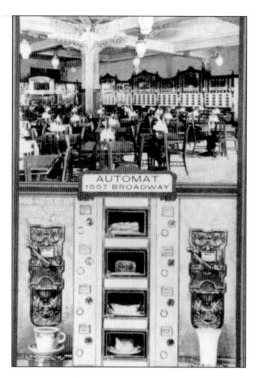

Hot drinks were vended through the gargoyle's mouth through similar action of a slot-dropped nickel. A high-quality cup of coffee, which retained its nickel price up to 1952, was an Automat hallmark. A cafeteria line was opened in time and the limited offerings diversified in the chain, which included more than 50 New York City restaurants at its peak. The Automat became so symbolic of New York life that it was featured on stage and screen. It became a place to spend time, as a diner could occupy his space as long as he desired, although the firm's pricing practice was low margin and high volume. The various outlets reflected the character of their surroundings, almost becoming neighborhood social clubs. In time, lingering undesirables created a problem for Horn & Hardart. (Courtesy of Charles Kleinman.)

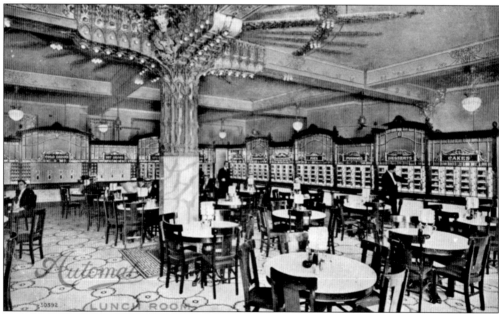

The Automat responded to change in various ways, including a minimum tab, hiring greeters (bouncers), raising the price of coffee to discourage loiterers, opening a take-out facility, and installing a Wild West Room at Times Square. However, time had passed it by. The formula of good, simple, and cheap food in a self-serve environment did not cut it in the emerging fast-food era. The Automat's decline began in the 1960s and soon accelerated, until the last one (p. 123) closed in 1991.

The 455-foot Paramount Building was erected by Famous Players – Lasky Corporation, the producers of Paramount pictures, on the west side of Broadway between 43rd and 44th Streets. The 31-story buff brick building designed by C.W. and George L. Rapp rose in a simple pyramidal mass with a series of eight setbacks. This literal interpretation of the 1916 zoning regulation was criticized when new for its aesthetic shortcomings. The tower, containing an observation deck, was topped by an illuminated globe that signaled the quarter, half, and hour marks with different flashes. The 26-foot clock face was one of the country's largest. The Paramount, the last major Times Square construction until well after World War II, completed the area's large-scale development, which began with the Times Tower. The second home of the New York Times in the area, once called the Annex, is visible in the left background. The 221-foot-high structure was built in three stages in 1912, 1924, and 1931.

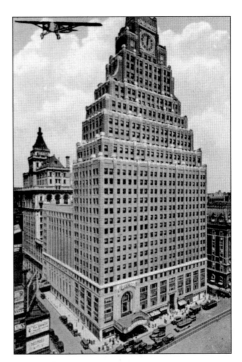

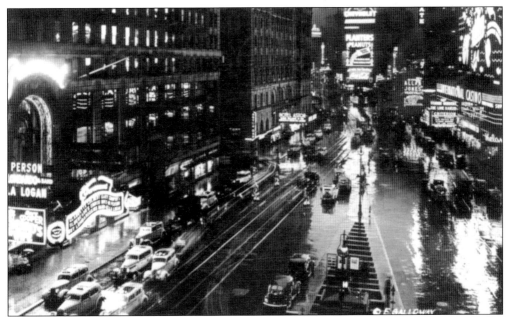

The Paramount Building included the 3,664-seat Paramount Theater (left), entered from Broadway but located behind the office tower. It was home to legendary performers over the years, including Frank Sinatra, but was removed in 1967 for expansion of office space. The basement was lowered in 1998 by removal of considerable bedrock in order to make the space suitable for restaurants and nightclubs. The lighted "International Casino" sign is barely visible in this 1938 photographic card, but on entering Times Square, one could not avoid notice of Benjamin S. Moss's high lettered sign on his 1936 Criterion Theater Building.

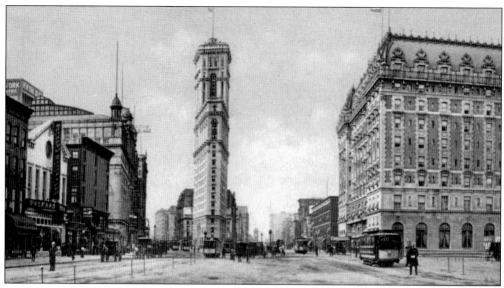

A view from the northern reach of Times Square (the section now known as Duffy Square) had a 1,200-foot-long clear vista of the Times Tower, a siting advantage recognized by its owner. That view of its north elevation is still a popular vantage for photographers; the suggestion of the photographic opportunity is pointed out in current guide maps. This *c.* 1905 Detroit Publishing view shows remaining automotive occupant Packard (left) on the block between 45th and 46th Streets.

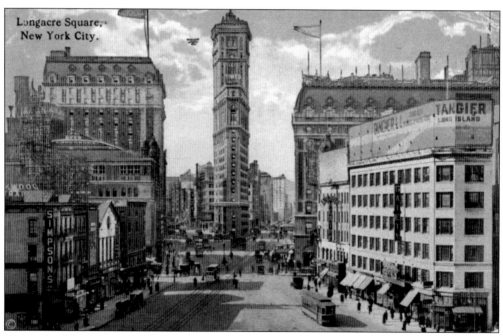

The Packard location was a billiard hall by the time of this 1911 card, while the Hotel Rector (p. 19) was a major addition to the east side of Broadway. On the west side, the Astor Theater was built in 1906 on the northwest corner of 45th Street, opposite the hotel, and the Gaiety Theater, designed by Herts & Tallent, was built in 1908, filling the remainder of the block.

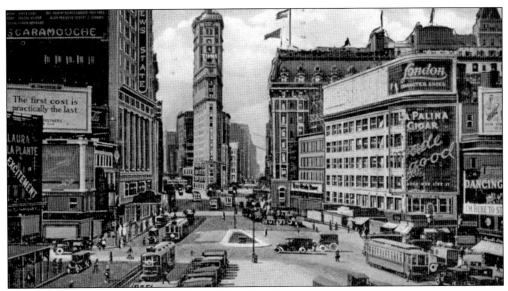

The Loew Building, designed by noted theater architect Thomas W. Lamb and built between 1919 and 1921 on the northeast corner of Broadway and 45th Street, included the Loews State Theater. This 1920s white border card shows a major expansion of signage.

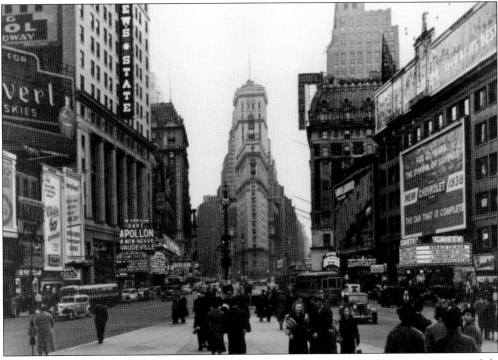

This 1938 image, indicating that films were shown at the formerly legitimate Gaiety, while vaudeville shared the Loews State, is a reminder that theaters' offerings varied over time. The 1927 Paramount Building looms over the Astor Hotel. The Childs's sign suggests the time's depressed economy: "All New York is talking about Childs' 60 cents dinner." This card was made in the late 1990s from a photograph in the city archives.

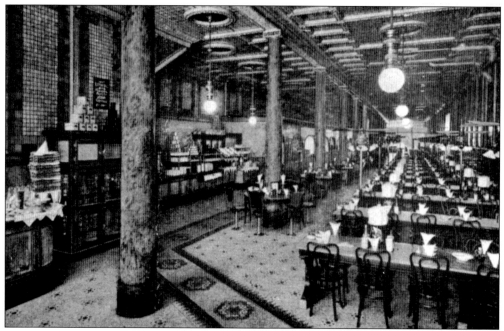

William and Samuel Childs founded their restaurant chain in 1889 as a quick-lunch establishment based on the principles of quality food and efficient service. Initially located downtown, the chain spread throughout the city, including Times Square and 42nd Street locations. Some of the restaurants were built with costly decor, but the cards rarely labeled the illustrated location.

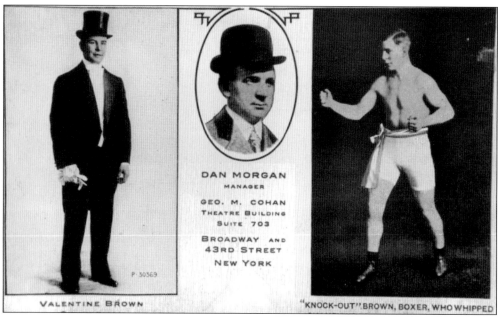

Dan Morgan probably used this card, perhaps dating *c.* 1913, for publi purposes in promoting his prizefighter Valentine Brown. George M. Cohan had a 12-story office building on the southeast corner; a three-story theater was adjacent on Forty-third Street.

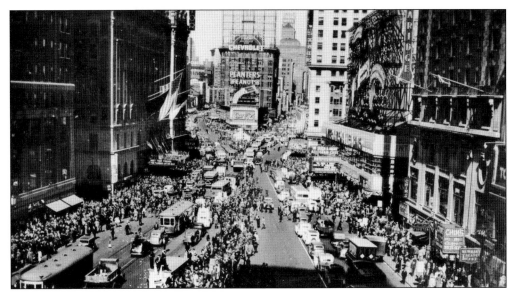

These masses, gathered in 1937, appear to be focusing attention on the Paramount for an undetermined reason or visitor. This photographic card provides a good view of the International Casino (right), an outstanding example of Art Moderne style, which possessed effective new technology. A contemporary writer equated a visit there with the Statue of Liberty, as must-see New York highlights.

The Buitoni Restaurant was squeezed in a narrow building located on the east side of Seventh Avenue between two theaters. Buitoni claimed that its starch-reduced macaroni was the oldest and largest selling brand. The area once had a number of spaghetti restaurants (back in its pre-pasta days), inexpensive eateries where huge pots of the product were typically cooked near the window. The card is a bright-colored linen example of a type that has given that style card newfound popularity for many subjects, including food. (Courtesy of Charles Kleinman.)

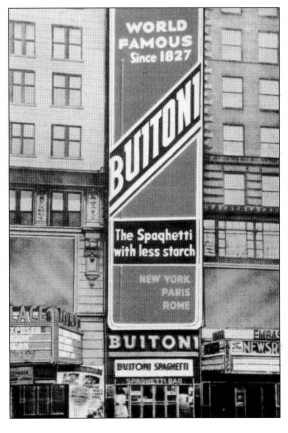

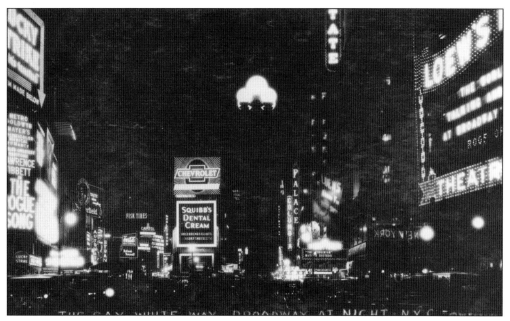

Even the original of this *c.* 1929 night view, a black-and-white photographic card, misses the excitement of the colored lights, but it is a reminder that all of the early signs were in white lights. The invention of color techniques, including neon gas *c.* 1915, quickly curtailed advertisers' acceptance of the white lights.

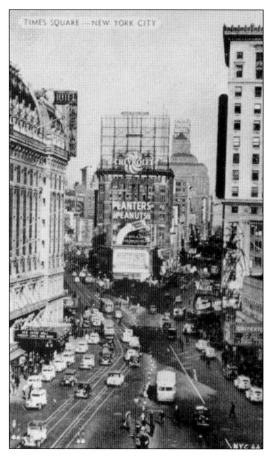

A 1934 view north provides a glimpse (right) of the Moss International Casino-Criterion Theater Building prior to erection of the casino sign. The principal product of Planters, one of Times Square's longest-running advertisers, has major nutritive value, but "a bag a day for more pep" now seems quaint. How many ate peanuts for energy, the term that long ago replaced "pep"? (Courtesy of Joan Kay.)

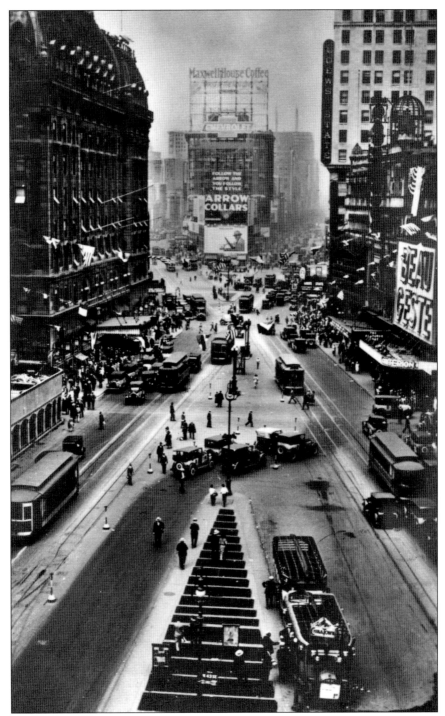

One of Times Square's famed signs is faintly visible on the frame over the Studebaker Building, Maxwell House Coffee's dripping cups, with their trademark slogan "Good to the Last Drop". The fence at the left appears to surround the Paramount's construction site, perhaps dating the image *c.* 1926.

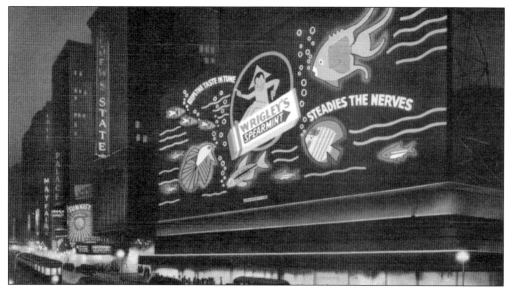

Built *c.* the late 1930s, Wrigley's, spanning the east side block from 44th to 45th Streets, was the most famed production of advertising sign pioneer O.J. Gude. The top of its frame was the equivalent of ten stories. The massive electrical project included 1,084 feet of neon tubing, nearly 70 miles of insulated wire, and 29,508 lamp receptacles with a $4,000 monthly electricity bill. Putting the animated display to work is said to have taken power sufficient to serve a city of 10,000—but only with appliances of the 1930s, of course. Operational costs were a reported $200,000 annually.

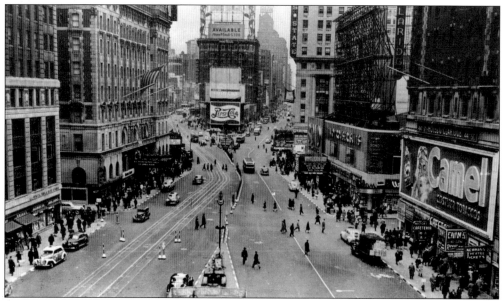

The Camel sign, one of master sign maker Douglas Leigh's greatest works, accommodated wartime blackout requirements by providing unlit visual stimulation, the regularly timed blowing of large smoke rings through a painted figure's open mouth. Mounted on the Hotel Claridge, it is seen on a 1941 photographic card, which indicates that signage in the surrounding area was notably diminished.

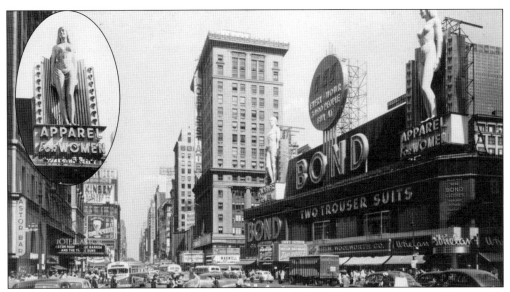

Bond Clothing, which took over the International Casino space *c.* 1940, mounted there one of the largest and greatest of Douglas Leigh's creations. It spanned the 44th–45th Street block, had two 50-foot-high figures at its ends, a 50,000-gallon, 27-foot-high, 120-foot-long waterfall between them, and a digital clock. The photographic card dates from 1948, when the sign was new (p. 44).

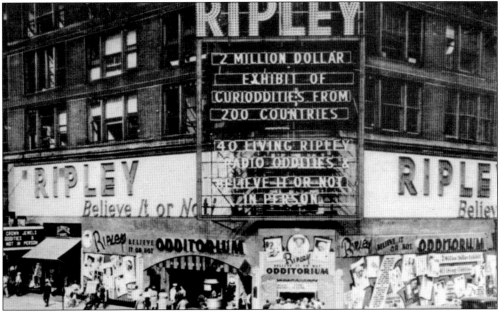

Ripley's had a wax museum, stage show, magic demonstration, and museum collection of its "Believe It or Not" peculiarities at Broadway and 48th Street. Pictured *c.* 1939, this showing of "curioddities" in a house called an "odditorium" ran through December 1971, when management, wary of a changed neighborhood, closed the place. Some of the content was more bizarre than odd. Indeed, the author rejected an available card of an exhibit as too gross for publication in a respectable book.

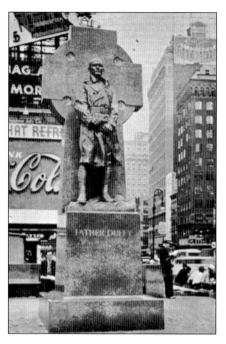

Francis Patrick Duffy, born in 1871 in Ontario, Canada, was educated there, ordained a priest in 1896, and taught at St. Joseph's Seminary from 1898 to 1912. After St. Joseph's, he moved to the Bronx to organize the Church of Our Savior. In 1914, Father Duffy was appointed chaplain of the 69th Regiment. He served with the regiment in the Mexican campaign and in France during World War I. There, the unit distinguished itself in the Argonne, earning the nickname of "the Fighting 69th." Duffy was appointed pastor of the Church of the Holy Cross (p. 81) in 1920, a time when the church served a tough Irish neighborhood not inappropriately known as Hell's Kitchen. He died holding that post in 1932. He is memorialized by the naming of the northern sector of Times Square as Duffy Square and by this statue, sculpted by Charles Keck and placed in the square in 1937.

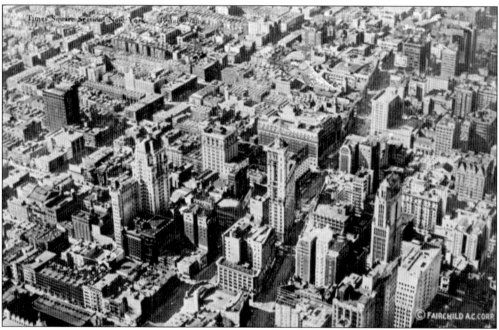

This early-1920s aerial view shows how the crossing of Broadway and Seventh Avenue make the "X" intersection of Times Square. The Times Tower (pp. 2, 15) is the tall building in the center, while the Bush Tower (p. 89) is at the right. The tall building west of the Times Tower is the 1914 Candler Building at 220 West 42nd Street, one not seen elsewhere in this book. The unusual gables of the Gerard (p. 60) make it easy to spot at the far right. The Hotel Astor (above the Times Tower) shows the later expansion that is not visible on page 23. To its left is the Times Annex, seen in an early state prior to expansion.

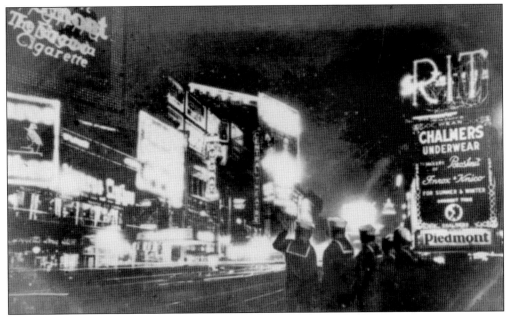

The relaxed social conventions of Times Square were accommodating to the desires of a variety of tourists, notably the military enjoying leave. While these sailors, pictured on a *c.* 1920s photographic card, were dazzled by the bright lights of night, they may also have been contemplating the pleasures readily found in the shadows' dimness. (Courtesy of Joan Kay.)

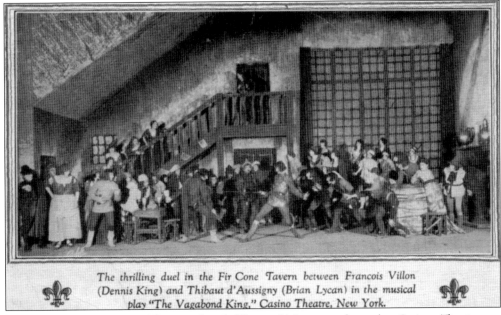

The thrilling duel in the Fir Cone Tavern between Francois Villon (Dennis King) and Thibaut d'Aussigny (Brian Lycan) in the musical play "The Vagabond King," Casino Theatre, New York.

In the four-act operetta *The Vagabond King*, which opened at the Casino Theater on September 21, 1925, and ran for 511 performances, poet Francois Villon, made "king for a day," must win the heart of Katherine de Vaucelles in that day. He (Dennis King) is seen in the duel scene with Thibaut d'Aussigny (Brian Lycan). The card was given to the attendees for mailing to encourage others to see the play.

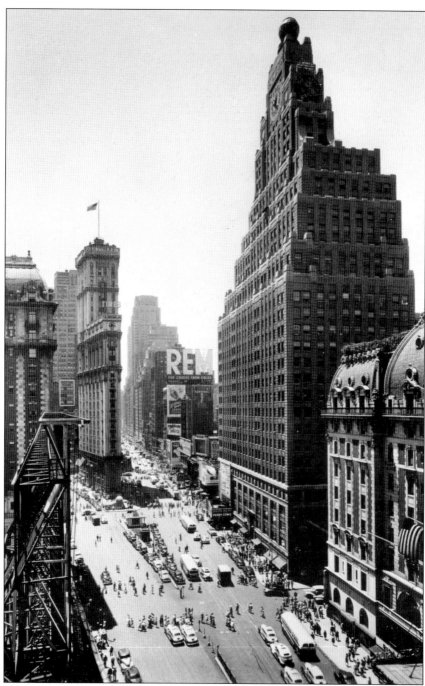

The view south from the International Casino roof dates from 1947, one year before the erection of the massive Bond sign (p. 37) on the frame at the left. A glimpse of the Hotel Claridge is above it, and the partial view of the Hotel Astor (right) clearly depicts its roof plantings and balcony. The armed forces recruiting station (rebuilt in 1950) in the middle of the intersection was the military's most productive. High rises fill the background; the Times Tower (pp. 2, 15) and the Paramount Building (p. 29) are in the center.

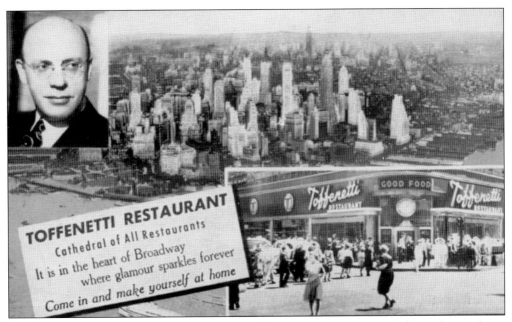

Chicago restaurateur Dorio L. Toffenetti opened his namesake eatery in 1940 on the southeast corner of Broadway and 43rd Street, specializing in traditional American food. Appealing to tourists and theatergoers, the place seated 1,000 and served about 3,000 meals per day. Nathan's opened there after Toffenetti sold the realty in 1968; the building was later demolished for the Condé Nast office tower.

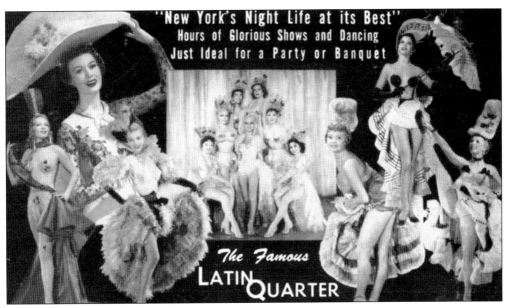

Lou Walters's Latin Quarter opened in 1942 at the Broadway and 47th Street building long occupied by a succession of nightclubs (p. 46). Operating on a premise of combining drink, scantily-clad girls, and a show, this nightclub was long one of the city's most popular. The Latin Quarter overcame a variety of obstacles over the years, but the place finally closed in 1969, prompted by real estate difficulties. However, by then times had passed the genre by.

41

This *c.* 1966 chrome shows the recently renamed Allied Chemical Tower with its new marble skin, the book's only streetscape that shows it without signs. The Scripto pen at the left was one of the square's larger three-dimensional signs. George M. Cohan, one of Broadway's greatest impresarios, is memorialized by the statue sculpted by George Lober and erected in 1959 in the Duffy Square island. Regrettably, the card does not show the side he undoubtedly would have preferred. (Courtesy of Moe Cuocci.)

The Big Top and "XXX" hits (for only $2.99) suggest the depths of the decline Times Square suffered in the 1970s and 1980s. Although the legitimate theater drew throngs at showtime, most New Yorkers avoided the area at any other time, and many altogether. The behind-the-scenes sin and vice reached a depth nothing short of depravity. The view is south on Broadway in 1986 on a John Kowalak photographic card.

Construction of major high-rise office and hotel towers was undertaken in Times Square in the late 1980s and throughout the 1990s. One important project that got under way even later was the Reuters Building at the northwest corner of Seventh Avenue and 42nd Street. Other significant sites are primed for development. The John Kowalak photographic card is a view looking south in the late 1990s.

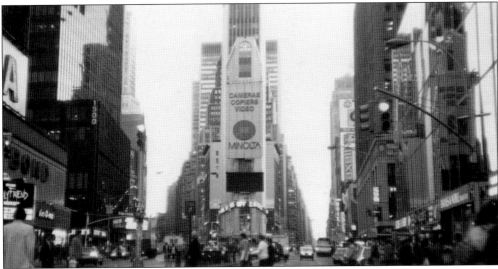

The New York Times mounted a moving electric light sign on its tower in 1928. Commonly called "the zipper," the sign was watched for breaking events in the era prior to the instant and continuous broadcast of news. The building has been emptied above grade and is effectively a gigantic billboard. What would be the top of tackiness anywhere else showcases the core of Times Square's character, so much so that current regulations require electric signs on new projects. Signs pay, too. Their net rental income at the pictured tower was reportedly $7 million annually.

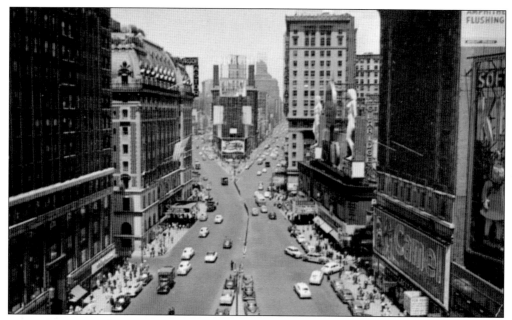

The Camel sign, picturing military men during World War II, had a variety of painted civilian faces afterward; they differ in these two *c.* 1950 chromes, which also depict a changed sign on the top of the Astor facade. The most interesting difference is in the appearance of the Bond statues, which during the day appear at first glance to be nude . . .

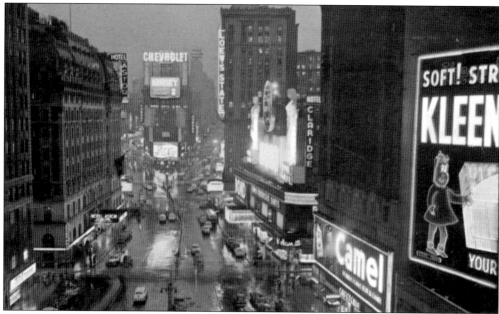

. . . but their strands of lights create the effect of a thin, filmy garment at night. At the right is a partial view of one of the largest and most intricate signs, Kleenex's, which wrapped around 43rd Street and featured "Kleenex" spelled with 16-foot-high letters. Little Lulu (where has she gone?) skipped from one side to the other and then slid on a tissue sheet into a 50-foot-long Kleenex box. The numbers reached 4,000 bulbs, 25,000 feet of neon tubing, and 500,000 feet of wire.

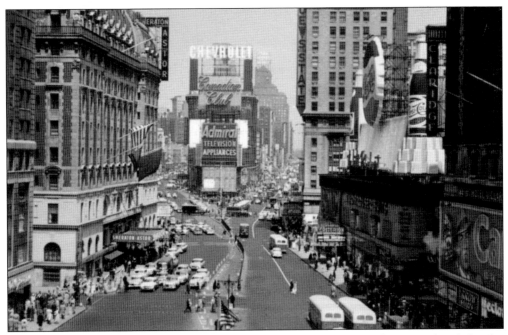

Pepsi succeeded the Bond sign, retaining the waterfall but replacing the figures with soda bottles and the clock with a huge bottle cap. Sheraton acquired the Astor in 1956, the probable year of this chrome, changing its sign as illustrated.

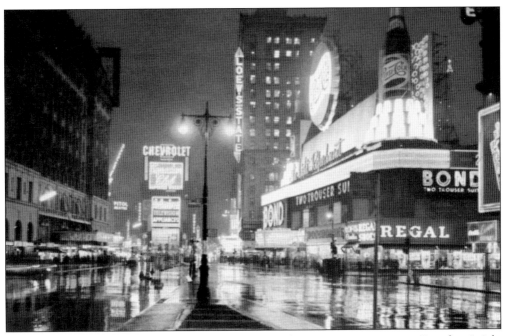

The Pepsi sign, viewed at night, lasted only a few years. Its creator, Douglas Leigh, maintained that advertising spectaculars needed an element of novelty to maintain an impact. The 103-foot-long Chevrolet sign, containing 8,900 white and yellow bulbs in 20-foot-high letters, had a 16-year run beginning in 1947.

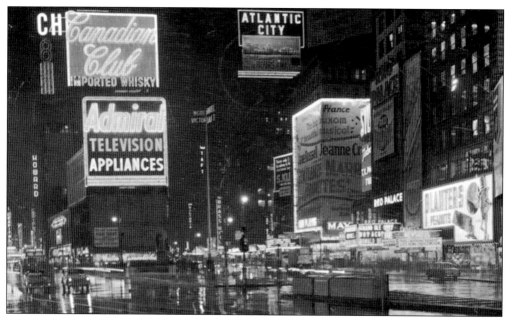

This *c.* 1955 chrome depicts in the shadows of the night the distinction between the old nightclub building, with the Admiral sign, and the Studebaker Building, which mounts the Canadian Club sign. The high-rise Renaissance New York Hotel, now on the site of the former, obscures the roof of the Studebaker Building. The blocks with the Brass Rail and Hotel Taft (background) can be seen on pages 72 and 73.

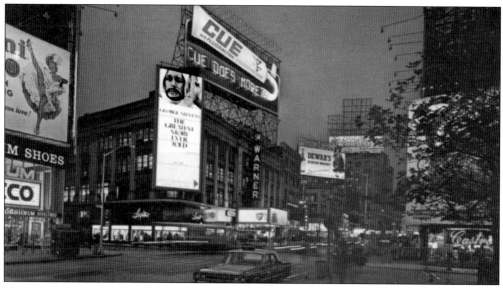

The Colgate-Palmolive Company first lit its 104-foot-long Cue toothpaste sign atop the Warner Theater in November 1965. The entire message pouring from the tube in 7-foot-high lights was, "Cue Does More for You." The company claimed the world's largest toothpaste "tube," 85 feet long and 20 feet high, would hold 28 million ounces—perhaps more than they ever sold. (What happened to Cue? Haven't a clue.) It was not the greatest advertising story ever told. The theater was demolished in 1987.

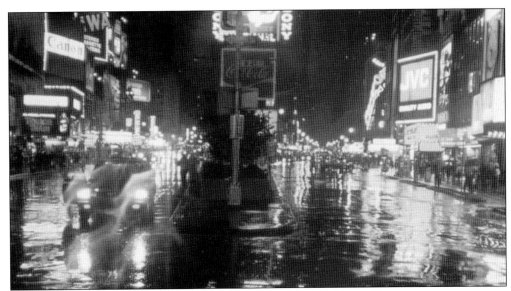

The exciting reflections of Times Square's bright lights in the rain is skillfully caught through the lens of Gail Greig. Its vantage at 45th Street is the spot where Broadway (left) crosses to the west of Seventh Avenue. Numerous Japanese firms have major signs at Times Square, dating from a time when many American firms shunned the area, as New Yorkers did. However, the Japanese reasoned that Times Square was such a magnet for tourists, their numbers merited advertising investment there, the former resolve of New Yorkers to stay away notwithstanding.

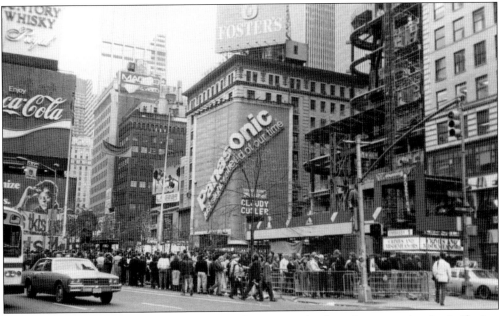

A large crowd is gathered c. 1989 at the Duffy Square island, perhaps queuing for half-price, same-day theater tickets at the "tkts" booth. The booth is barely visible in the background behind Father Duffy (p. 38), seen on a John Kowalak photographic card. The Doubletree Guest Suites Hotel is pictured under construction on the southeast corner of Seventh Avenue and 47th Street, and the light post is a second thwart to a good view of the George M. Cohan statue (p. 42).

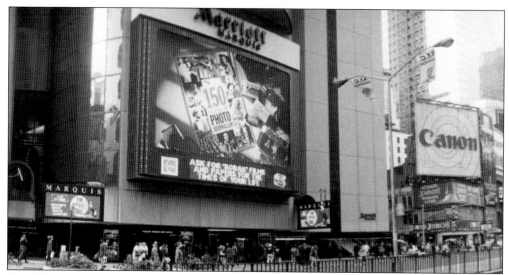

The 54-story New York Marriott Marquis Hotel, designed by John C. Portman Jr., was built between 1982 and 1985 on the west side of Broadway, between 45th and 46th Streets. This was the site of the former Astor and Gaiety theaters (pp. 30, 31). The building, seen on a 1990 John Kowalak photographic card, contains two theaters, but its eye-catching feature is this enormous illuminated Kodak sign facing Broadway. The structure consists of two massive concrete slabs facing away from the street (bottom of p. 42), so designed as Times Square was in the depth of decline when the building was planned in the 1970s.

The sign denotes the "Bertelsmann Building," designed by Skidmore, Owings, & Merrill and built in 1990, but the image is the clutter of the lower levels of its Broadway facade, which fills the block formerly the site of the Loew Building (pp. 30, 31). A sleek, 45-story office tower rises over the street's clutter, while an extensive shopping lobby and an underground movie theater are inside. The 1990s image is by photographer-postcard publisher Gail Greig.

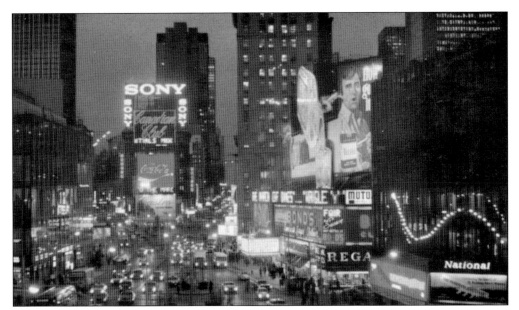

The Bond sign also included a moving light "zipper," which shows a message in this *c.* 1972 night scene. By then, an ever-pouring gin bottle and smoker had taken over the top. The "zipper," once a novel addition to the Times Tower (p. 43), is now omnipresent in Times Square. Since any viewer can absorb only so much news and so many ads, some "zippers" now display securities quotations.

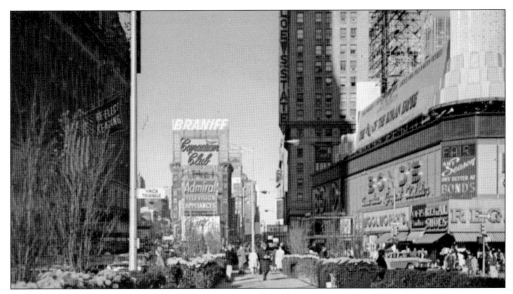

Temporary names honoring events or organizations have from time to time supplemented the Times Square designation. The southern part of the island formed by the Broadway–Seventh Avenue crossing was renamed for the YMCA *c.* 1964. Contemporary names include two temporary designations for the streets forming the triangular island, NYC 2000 Way and Millennium Way. Note the building at the right, photographed as the Pepsi sign (p. 45) was being dismantled. Many area streets now have supplementary names honoring those significant to the history of the area.

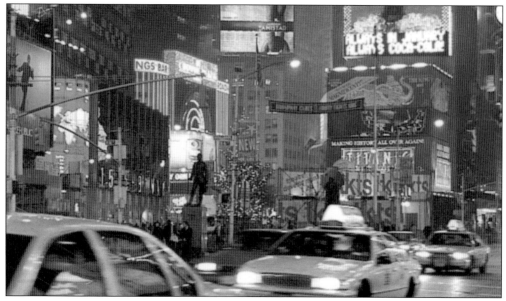

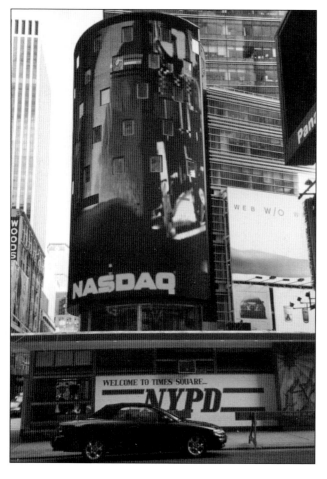

Contemporary Times Square at night is an explosion of color. The south facade of the Renaissance New York Hotel (right) has been a veritable high-rise billboard since its 1994 opening. The bright lights to the left of the Renaissance belong to the Crowne Plaza, seen behind the silhouette of the George M. Cohan statue. Barely visible farther to the right is the multistory zipper sign at 1585 Broadway.

The Condé Nast Building was completed in 1999 on the east side of Broadway, spanning the block from 42nd to 43rd Streets. Its 43rd Street corner is highlighted by one of Times Square's all-time spectacular light displays, the multicolored, ever-changing NASDAQ sign, which was made operational only recently. Since Times Square is a prime subject for contemporary postcard production, the sign can be expected to be published in the future. However, it appears first here as a photograph.

Two

WEST TIMES SQUARE

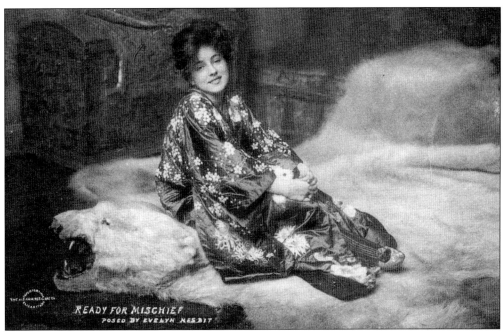

A 16-year-old Evelyn Nesbit arrived in New York from Pittsburgh, worked as a photographer's model, and later won a role in the prestigious Floradora Sextette. While performing with them, she fell under the lecherous spell of fashionable architect Stanford White, a relationship that assured her enduring fame, or notoriety. She married the unstable, insanely jealous Harry Thaw, who, resentful of his wife's former relationship with White, murdered him on June 25, 1906. Nesbit worked in vaudeville, attracting audiences for a while but enduring a dismal existence. She died in Hollywood at age 81 in 1966. (Collection of Karen L. Schnitzspahn.)

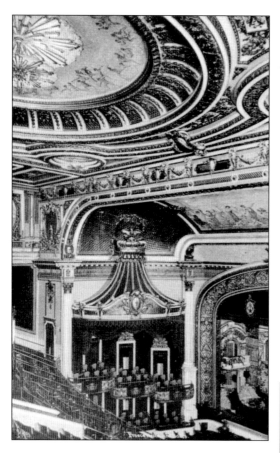

The Strand Theater, designed by Thomas W. Lamb, was completed in 1914 at the northwest corner of Broadway and 47th Street, the site of the former Brewster carriage factory. Although it was the first of the great movie palaces, the exhibition of films had not been determined until shortly before its opening on April 11, 1914, when *The Spoilers* was screened. Under the management of S.L. "Roxy" Rothafel, the Strand presented musical comedy and a musical performance (by either an orchestra or its Wurlitzer organ), in addition to a film. The success of the 3,500-seat Strand was followed by increasingly elaborate theaters, making the 1920s "the age of great motion picture palaces," culminating in Rothafel's namesake Roxy in 1927 (p. 72). This card of the interior dates from *c.* the 1920s. Later known as the Warner, a night view of the exterior can be seen on page 46. The Strand/Warner was demolished in 1987.

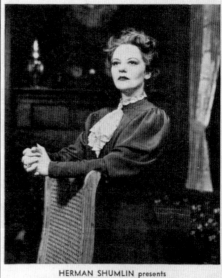

"Here is another fine and important American drama."
—WATTS, Herald-Tribune
"The season's most tense and biting drama."
—TIME MAGAZINE

HERMAN SHUMLIN presents
TALLULAH BANKHEAD
in "THE LITTLE FOXES"
LILLIAN HELLMAN'S NEW DRAMATIC TRIUMPH
with PATRICIA COLLINGE and FRANK CONROY
NATIONAL THEATRE WEST 41st STREET, N. Y. C.
Nights: Orch. $3.30; Bal. 55c, $1.10, $1.65, $2.20, $2.75
Matinees Wednesday and Saturday 55c to $2.75

Lillian Hellman's drama *The Little Foxes* opened on February 15, 1939, and ran for 410 performances. Tallulah Bankhead is seen on a widely circulated publicity photograph, this example on a "viewer as critic" postcard. If her countenance seems overly stern, be mindful one critic called the drama, "a grim, bitter and merciless study."

Even with the addition of a marquee and absent its roof balustrade, today's Helen Hayes Theater at 238 West 44th Street is readily recognizable as the former Little Theater, designed in the Colonial revival style by Ingalls & Hoffman and completed in 1912. As its name implied, the house was small, originally seating only 299. It was built by producer-director Winthrop Ames for the production of small, intimate plays not suitable for the typical larger auditorium. The place was enlarged between 1917 and 1920, addressing a profitability problem, but at 499 seats, the Helen Hayes is still the smallest legitimate house on Broadway. The Little Theater, with a history that includes spells occupied by broadcast companies and the New York Times, was designated a New York City landmark in 1957.

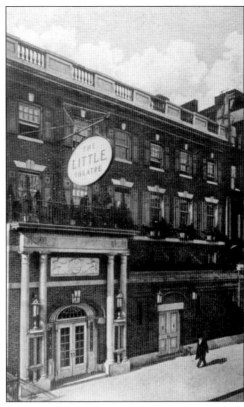

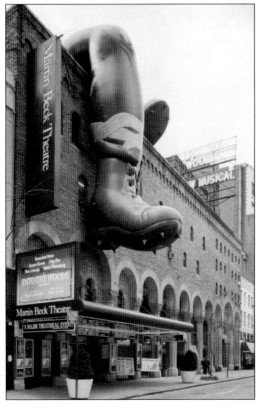

Martin Beck, a principal vaudeville impresario, built his Moorish-style namesake theater in 1924 at 302 West 45th Street, west of Eighth Avenue. Its location just beyond the traditional boundary of the theater-Times Square districts did not impede the house's popularity. The Martin Beck's architect, C. Albert Lansburgh, although primarily a designer of movie theaters, designed a particularly rich interior for this 1,200-seat theater. Both interior and exterior were designated New York City landmarks in 1987.

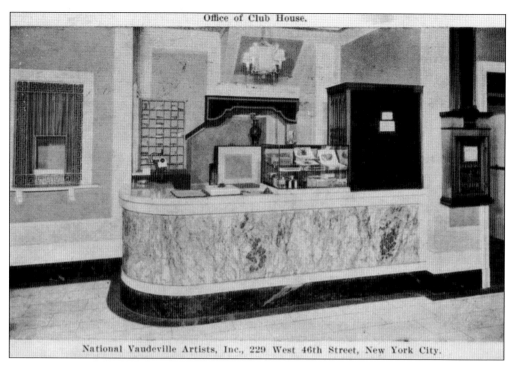

Office of Club House.

National Vaudeville Artists, Inc., 229 West 46th Street, New York City.

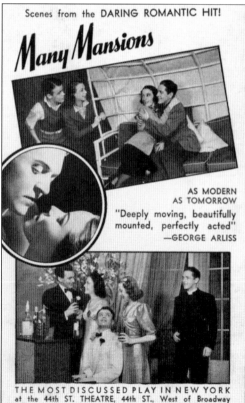

Scenes from the DARING ROMANTIC HIT!

Many Mansions

AS MODERN
AS TOMORROW

"Deeply moving, beautifully
mounted, perfectly acted"
—GEORGE ARLISS

THE MOST DISCUSSED PLAY IN NEW YORK
at the 44th ST. THEATRE, 44th ST., West of Broadway

Edward F. Albee created National Vaudeville Artists Inc. in 1916 as a company union to foster vaudeville managers' control of the performers. He acquired the 229 West 46th Street clubhouse of the White Rats, an artists' union, following that union's ill-fated, unsuccessful 1917 strike. Actors paid an annual $10 fee for access to the elegant "home away from home." Its office is pictured in the 1920s; the place was sold in 1937, after Albee's death, as he left no funds for its maintenance.

Many Mansions starred Alexander Kirkland and Flora Campbell in its run at the 44th Street Theater. This card was issued by management to attendees for publicity purposes. One does not have to be a cynic to wonder if theater "censors" mailed only those with favorable comments. Since the card appears 50 or more years old, one suspects its daringness would hardly be noticed in 2000.

St. Luke's Lutheran Church was organized in 1850, occupying various quarters prior to purchasing a former Presbyterian church on the north side of 42nd Street, between Seventh and Eighth Avenues. That property was sold and this church was erected at 308–316 West 46th Street, west of Eighth Avenue. The Gothic-influenced edifice, designed by Edward L. Tilton and Alfred Morton Githens, was completed in 1923, a number of months after the congregation rented the Selwyn Theater for temporary use while awaiting completion of its new home. The parish has long been known as "the Lutheran Church of Times Square"; its church is seen on a *c.* 1940s monochrome.

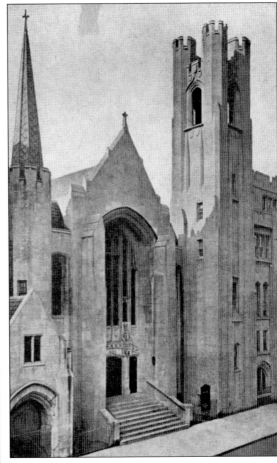

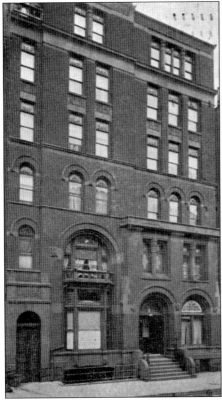

Alliance House, a *c.* 1900 residence of uncertain origin, still stands at 258–260 West 44th Street, unrecognizable until one examines the upper floors. Storefronts for restaurants and two stories of stucco mar the dignity of the original design. (Courtesy of Charles Kleinman.)

55

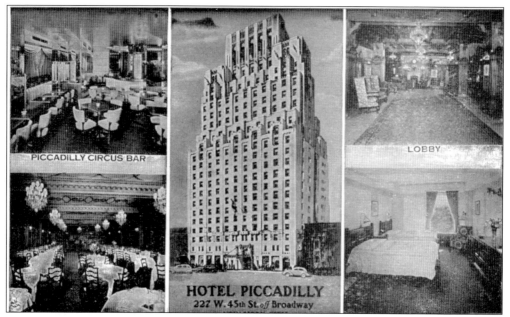

Designed by George Edward Blum and S. Walter Katz, the 26-story, 280-foot Hotel Piccadilly was built by the Paramount Hotel Corporation at 227 West 45th Street. The 600-room facility, pictured *c.* 1940, was completed in 1928.

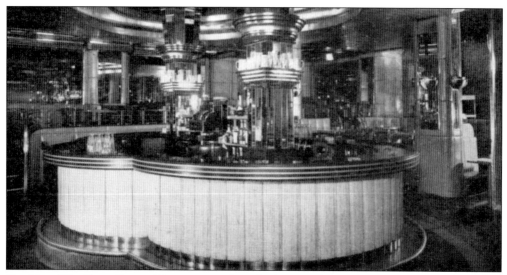

The Piccadilly Circus Bar and Lounge was described in a 1948 dining guide as a "gaily colorful spot in the thick of theaterdom patronized by show folk and show-goers." The *c.* 1940 Lumitone card reflects sleek Art Deco finishing.

The 15-story, 1,000-room Hotel Times Square was completed in 1924 at the northeast corner of Eighth Avenue and 43rd Street. The place was briefly named for its builder, Henry Claman, who is honored by a plaque at the entrance. Renamed the Times Square Motor Hotel in 1963, the huge hostelry has had a checkered past but has risen with the renascence of Times Square itself. Once a notorious welfare hotel, it has been redeveloped by the Times Square Common Ground Community with 652 efficiency apartments as "multi-faceted affordable housing developed for single adults and the largest supportive housing facility in the nation." The Hotel Times Square is listed on the National Register of Historic Places.

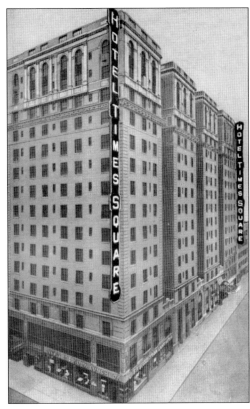

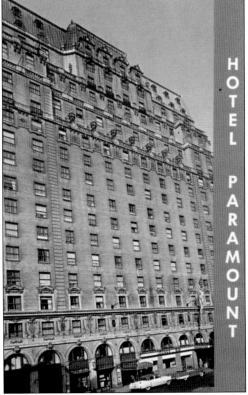

The 252-foot, 700-room Hotel Paramount, designed by Thomas W. Lamb, was completed in 1928 at 235 West 46th Street, west of Broadway. It was well known for the Paramount Grill and as the home of Billy Rose's Diamond Horseshoe. The place was closed in 1988 for an 18-month remodeling project and reopened in 1990 under the ownership of Ian Schrager, who retained the Paramount name. The exterior appears unchanged, but the lobby has a new character. Designed by Philippe Starck, the striking interior was planned for "offering the best of New York City in its lobby . . . so many enticing alternatives—stylish restaurants, cozy bars and pulsing nightlife—that visitors" will not even be tempted to "leave the premises." The card is a 1950s chrome.

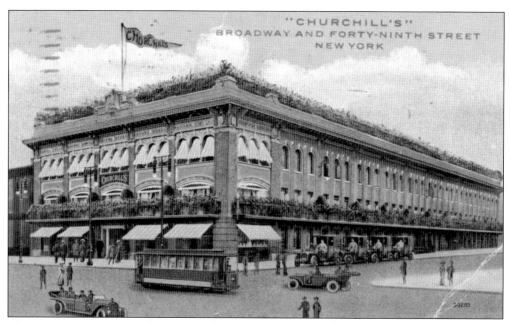

Churchill's Restaurant was located on the southwest corner of Broadway and 49th Street. The building was remodeled into a theater in the 1930s and was demolished in 1986.

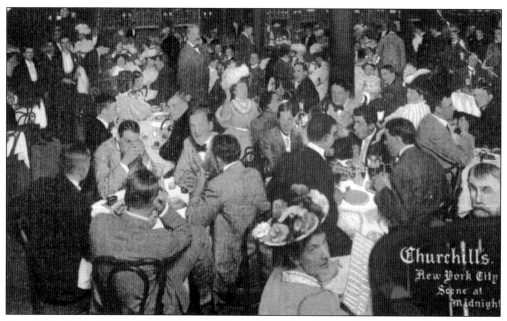

Churchill's is depicted *c.* 1910 with a well-dressed, well-to-do post-theater crowd.

Many of the better restaurants offered musical entertainment in their early days. Churchill's Elizabeth Spencer, pictured *c.* 1910, has an elusive historical record, if any at all, but presumably meriting your own postcard then reflected stature. Another restaurant, Shanley's, was a defendant in landmark litigation that was decided by the Supreme Court of the United States in a ruling in favor of composer-plaintiff Victor Herbert that helped secure royalty rights for artists. (Courtesy of Joan Kay.)

Joel's, at 206 West 41st Street, ambitiously compared itself to Maxim's in Paris. Claiming to seat 1,000, Joel's, showing no reluctance for self-promotion, declared a visit there would place one in the presence of "New York's true bohemians, actors, artists, and newspaper folk—the most lovable people on earth."

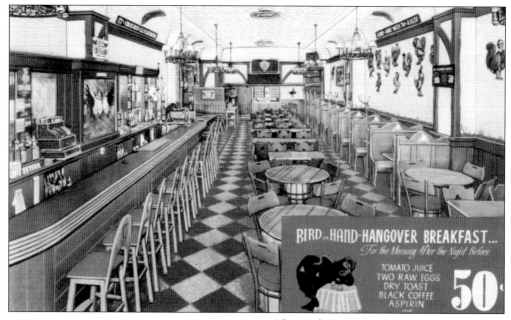

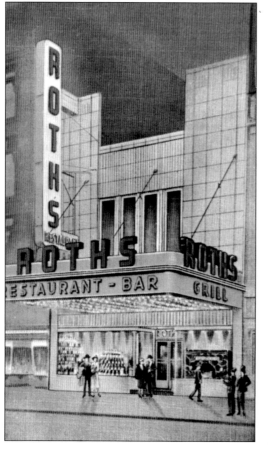

The Bird in Hand (the only way to consume their specialty) claimed world fame for its southern fried chicken and offered a hangover remedy, readable on a colorful c. 1940s linen card. Instead of the sympathy, perhaps they should have offered encouragement not to overindulge. A printed message in the corner stamp box proclaimed, "U Write 'Em We Gladly Mail 'Em" (provided that the hung-over penmanship was still readable).

Bright colors and an attractive Art Deco exterior lent appeal to a c. 1940s linen card for Roth's Grill and Restaurant at 1599–1601 Broadway. Many booths lined its interior, which also included a big bar. Roth specialties included sauerbraten and boiled short ribs of beef. (Courtesy of Joan Kay.)

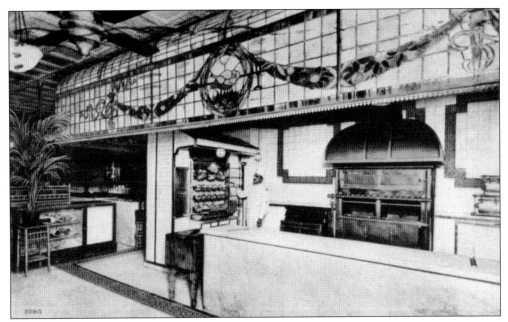

The owners of the Elderado Restaurant, a prior occupant of 1599–1601 Broadway, declared themselves "kings of roast meats," adding the assertion that they originated this style of cooking. The interior is depicted *c.* the 1920s on a white border card. (Courtesy of Charles Kleinman.)

Artist and Writers Restaurant

213 WEST 40TH STREET · NEW YORK CITY · LONGACRE 3-9050

LUNCHEON • DINNER • SUPPER

Artists and Writers Restaurant was a notable hangout for the newspaper crowd, many of whom affectionately called it "Bleek's," for founder Jack Bleek. The congenial hosts were "Fitz" and "Hitz," whose watering hole, so fond to the fourth estate, was at times worked into newspaper stories. The card is a *c.* 1940s Lumitone; the place is now a fabric shop.

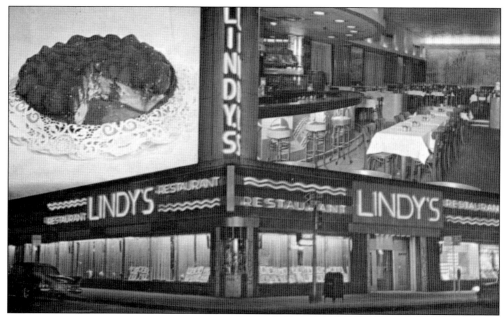

Leo and Clara Lindemann founded a deli at Broadway and 51st Street in 1921 and later a second one across the street. The multiview late-1950s chrome shows their famed offering, a rich, creamy cheesecake. Lindy's, also known for its theater following and arrogant waiters, who were part of the presentation, was regularly mentioned in Damon Runyon's writings. Both early restaurants are long closed; the present use of the name has no tie to the original.

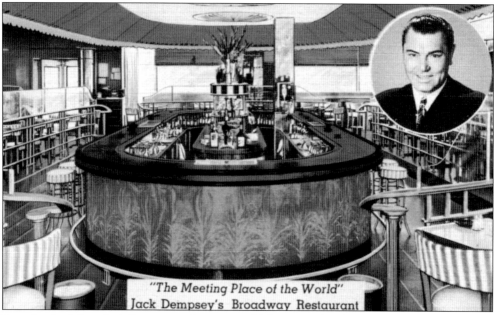

"The Meeting Place of the World"
Jack Dempsey's Broadway Restaurant

Famed prizefighter Jack Dempsey, who was world heavyweight champion from 1919 to 1926, provided ready access to the featured attraction in his celebrity restaurant at Broadway and 49th Street. He sat in the window to meet and greet, while the back of his 1940s linen postcard exclaimed, "Come in and say hello!" (Courtesy of Gary Dubnik.)

Three

EAST TIMES SQUARE

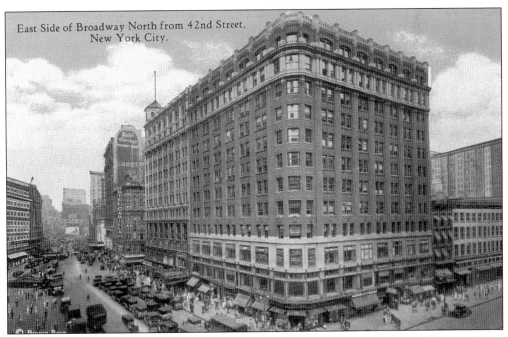

East Side of Broadway North from 42nd Street, New York City.

The Longacre Building at the northeast corner of Broadway and 42nd Street, built in 1912 to a design by Clinton & Russell, was located only a few yards across the street from the Times Tower (which was artistically omitted from this *c.* 1918 card). However, it appeared to many observers to belong more to the 42nd Street block to its east rather than the square. It was planned to be harmonious with the Fitzgerald Building to its north. The site of both buildings is now occupied by the 1999 Condé Nast Building (p. 50). The Times Square district on the east embraces its adjacent side streets to Sixth Avenue, although at least one hotel east of Sixth (p. 68) promoted itself as part of Times Square. The designations "east" and "west" have no known written or spoken application to Times Square but are used only to provide convenient chapter divisions.

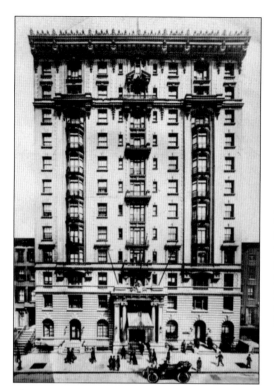

The Woodstock, a mid-block hotel built *c*. 1908 at 127 West 42nd Street just east of Broadway, was an early success, an inference from its having expanded on the west only a few years after construction. The handsome Beaux Arts-style hotel stands little changed, now occupied as a senior citizens residence. The entrance columns and entablature are gone, while the elaborate cornice was stripped of its decoration. The Hotel Woodstock published many postcards over the years; often the backs were printed with an advertising message. This *c*. 1910 photographic card is linked with a same period card of its interior. Hotels and motels often depict interiors with a glowing image that outshines the actual premises. The author has evaluated for years the "invitational quality" of such cards, searching for a "visit me" character, but to him the Woodstock lobby . . .

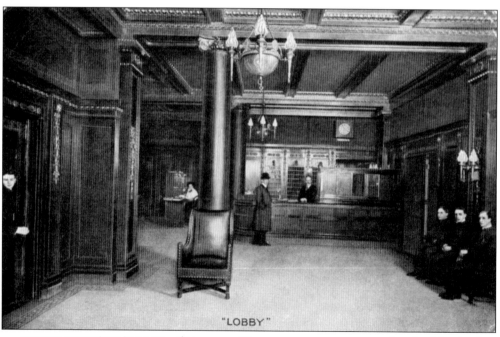

"LOBBY"

. . . appears mysterious in an unwelcome way. These responses are personal and subjective, but one can imagine entering here and never returning. The much-changed lobby was reduced in size and is neither inviting nor mysterious today. Those floor tiles provide an interior link with the Woodstock's origins.

New York Lodge No. 1 of the Benevolent and Protective Order of Elks opened its 43rd Street clubhouse in 1911, a time when fraternal organizations were enjoying rising membership and growing financial capabilities. The architect of this 14-story, Neo-Classical structure was James Riley Gordon, who had earlier designed the Elks' Bronx lodge. The facility, with 240 rooms and a main ballroom with a 32-foot-high ceiling, was, in effect, a city hotel for visiting Elks. The Depression hit fraternal organizations hard. Their business diminished while they retained major operating expenses, the likely cause for its 1932 opening to public guests and 1934 foreclosure. The place was later a modest-priced hotel, first the Delano, then the Diplomat, and in time, a single-room occupancy hotel for long-term residents. The hotel was acquired by real estate interests and demolished *c.* 1990 for inclusion in a prime development assemblage. (Courtesy of Charles Kleinman.)

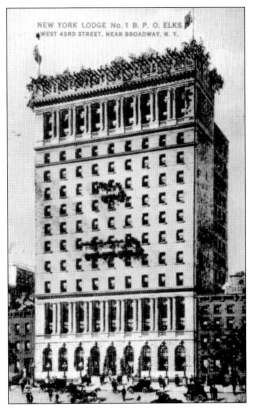

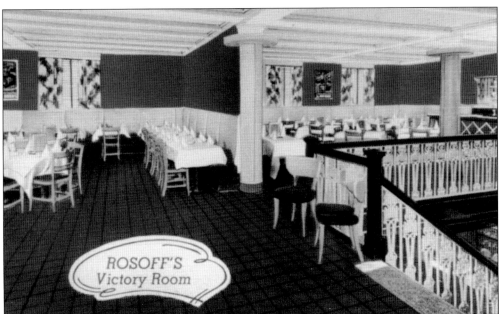

Rosoff's *c.* 1940 linen card had enormous visual appeal through its bright red color. Located at 147 West 43rd Street, the establishment's advertising claim was modest: "Always Something Good to Eat." One infers the Victory Room had a World War II tie. (Courtesy of John Rhody.)

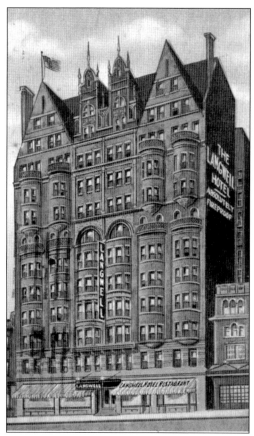

The Gerard was an apartment hotel designed by George Keister and completed in 1894 at 123 West 44th Street, named for William B. Gerard, its operator. The brick, limestone, and terra-cotta clad building foretold the neighborhood's extensive change; when new, its 13 stories made it the highest in its surroundings. This white border card, a rendering that effectively portrays the handsome building's gables, curved bays, dormers, and minarets, depicts the Hotel Langwell name, which was adopted after its sale by its builders, the Rankins. A later change was the Hotel 1-2-3, surely the least inspired name in New York. The building, a New York City landmark, is still occupied as a residence.

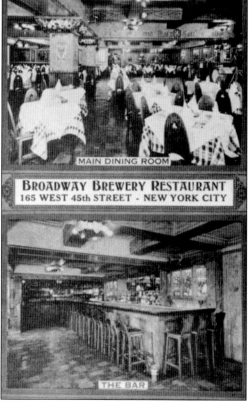

The micro brewery within a restaurant, a genre that made a small presence in the culinary scene in the 1990s, had an antecedent, at least in name, at 165 West 45th Street, occupied in the 1940s by the Broadway Brewery Restaurant. (Courtesy of Joan Kay.)

66

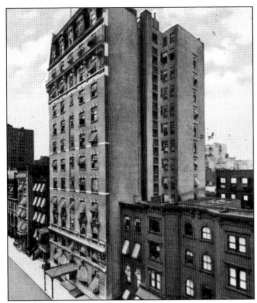
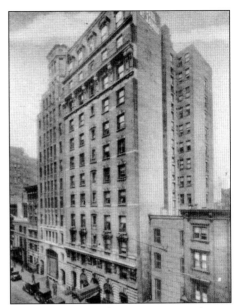

Two views of the Hotel St. James, completed *c.* 1913 at 109 West 45th Street, are shown, when new and about 30 years later. The hotel is a New York rarity, having done business at the same location and with the same name for nearly nine decades. The place is recognizable, although missing its cornice and brackets. The brownstones at the right, showing an interesting but not pleasing remodeling, were replaced by a high rise. The later tall neighbor to the left still stands.

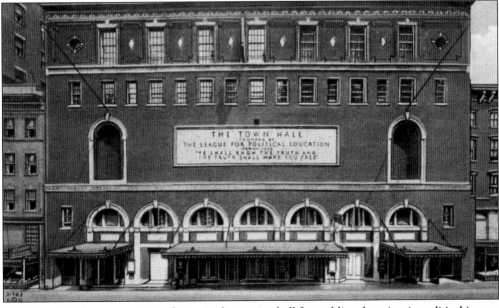

The Town Hall began as a City of New York meeting hall for public education in political issues. The fine Colonial Revival building, a city landmark, was completed in 1921 at 113–123 West 43rd Street, designed by the firm of McKim, Mead, & White. Speakers of international renown have appeared in the Town Hall's auditorium. In recent years, the place has been used substantially as a concert hall.

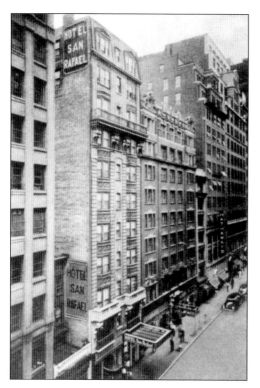

The San Rafael, a smaller hotel built *c.* 1910 at 65 West 45th Street, was east of traditional Times Square area boundaries. However, on the back of this 1930s card, the hotel proclaimed to be in the "Heart" of Times Square, as well as one block from Fifth Avenue and three blocks from Radio City, the early name of Rockefeller Center. The hotel no longer stands, its demise probably dating from the *c.* 1970 planning of 1166 Sixth Avenue, which is now on the site. That building's plaza is south of the avenue because one of the buildings in the center of this card was a holdout through construction of the skyscraper at 1166. The taller building right of the hotel stands at No. 49, while the seven-story adjacent structure occupies No. 55. (Courtesy of Joan Kay.)

The Church of St. Mary the Virgin was founded in 1868. That year the church began construction of an edifice on West 45th Street, which was opened unfinished on December 8, 1870. The present, larger church was built in 1894–1895 at 145 West 46th Street, following receipt of a substantial bequest from a parishioner. Designed by Napoleon LeBrun & Sons, the beautiful interior has been richly decorated since pictured *c.* 1908. A large crucifix hangs from the front of the nave, the windows are stained-glass, and a 25-foot pulpit, the masterpiece of woodcarver Iohann Kirchmayer and one of St. Mary's greatest treasures, was installed. Statuary is throughout. St. Mary the Virgin worships in the Anglo-Catholic tradition; the primary purpose for which it exists is the celebration of the Mass. Commercial development has so enveloped the church that one can pass by repeatedly without realizing a house of worship is near. It is well worth a look inside.

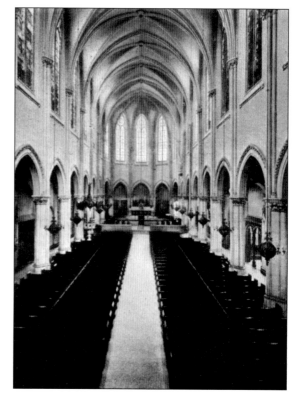

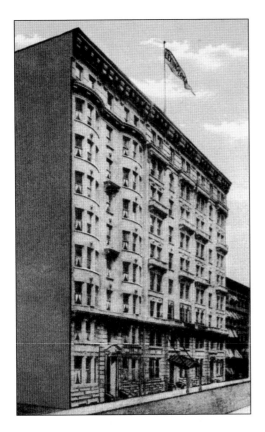

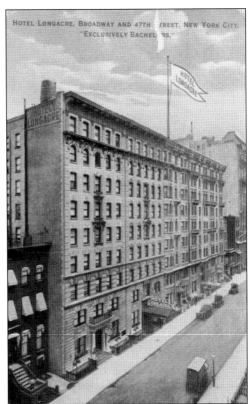

The Lexington Hotel (left) is pictured *c.* 1905 on the north side of 47th Street, one-half block east of Times Square, probably when new, and about ten years later. The establishment, appearing to be five joined buildings, was then the Hotel Longacre, cultivating an exclusively bachelor clientele; it was the Hotel America in a later incarnation. The added sections at the left survive as the Hampshire Hotel & Suites at 157 West 47th Street; the original buildings to their east were replaced by a parking garage.

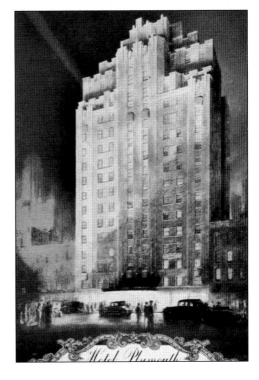

The 18-story, 400-room Hotel Plymouth was completed in 1929 on 49th Street, east of Broadway. Pictured on a *c.* 1940 Lumitone, the place had a cabaret.

69

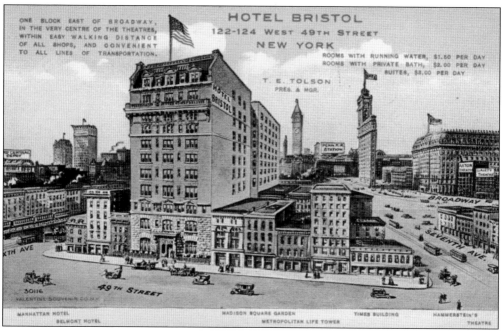

The Hotel Bristol published a highly stylized sketch of its West 49th Street locale *c.* 1910, about when the place was built. The image brings it a little closer to the Square proper but also eliminates two competitors, the Maryland to the east and the Van Cortlandt to the west. The hotel survives as the Radio City Apartments. The new McGraw-Hill Building is on the corner at the left.

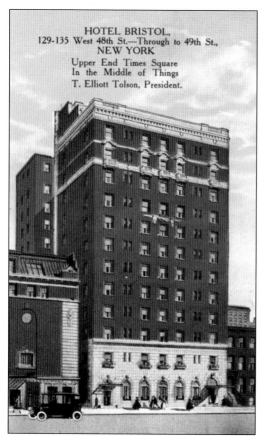

The Hotel Bristol admitted on this *c.* 1920 card that, although its 48th Street extension was a block closer, it was still "upper end" Times Square. *Wonder City* indicated that this building was erected in 1918, had 15 floors, and contained 410 rooms. The capacity likely included both buildings, and one suspects that they were counting a basement, because neither are there three stories above the cornice nor are they full floors. This part of the Bristol no longer stands. A glimpse of the 1911 Playhouse Theater is at the left. It was demolished *c.* 1969, likely also the time of the demise of the Bristol.

The Renaissance-style Van Cortlandt was likely built *c.* 1910, a period when a number of smaller hotels were erected to address a shortage caused by the early success of Times Square. This success, however, was not satisfied until the hotel building boom of the 1920s. The no-longer-standing hotel belongs a couple of doors to the right of the Bristol in the image on the top of the opposite page.

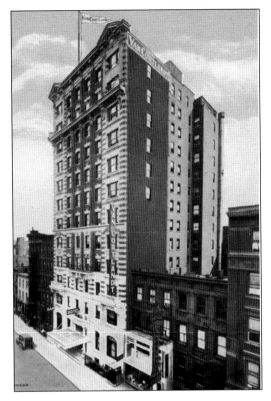

Nils T. Granlund, a press agent, developed his Hollywood Restaurant *c.* 1929 as a new entertainment medium, the nightclub, which eschewed illegal Prohibition-era liquor and high cover charges. A good meal (with a minimum charge), a show, and scantily clad girls pioneered a formula replicated elsewhere in Times Square.

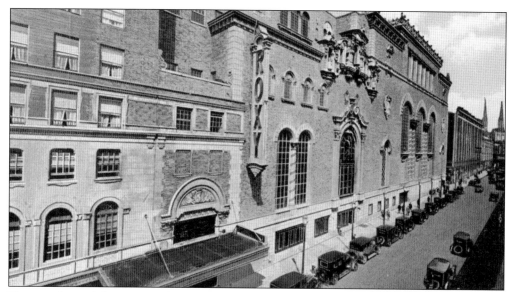

The grandeur of the Roxy at the pinnacle of the great age of motion picture palaces may be inferred by the Cathedral of Movies label attached to it by the *New Yorker*. The 6,200-seat theater, bearing the nickname of its impresario Samuel Lionel "Roxy" Rothafel, was the work of architect Walter W. Ahlschlager, with art designer Pietro Ciaverra. It opened March 11, 1927, and immediately achieved good popular success, but with a following not embraced by the intelligentsia. The extensive facilities included a 110-person orchestra pit. The theater closed and was demolished in 1960.

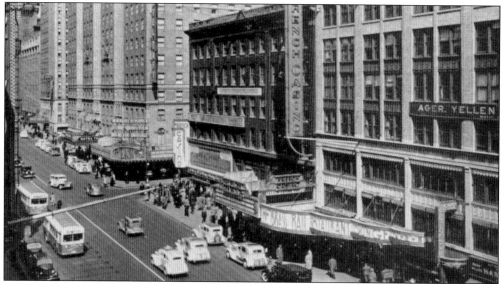

The French Casino was a mid-1930s incarnation of the failed second Earl Carroll Theater at the southeast corner of Seventh Avenue and 50th Street. Clifford Fisher installed a theater-restaurant, which opened on December 25, 1934, lasting into 1937, when it was remodeled by Billy Rose. It is pictured *c.* 1935 with the popular Brass Rail Restaurant on a block that was recently leveled for new construction, which is under way today. The Roxy's 400-foot marquee was built into the corner of the Manger-Taft.

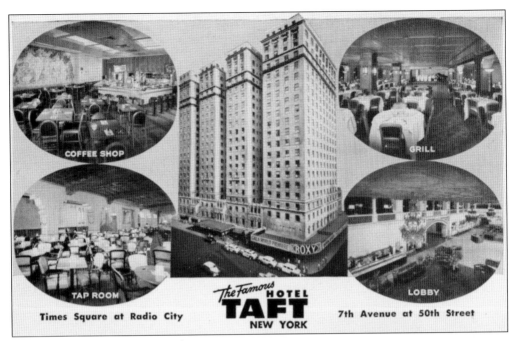

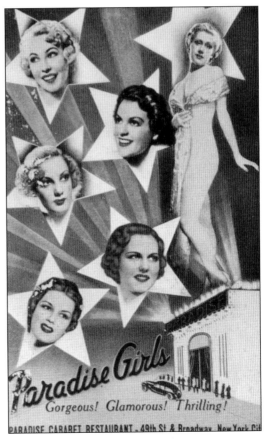

The 21-story, 222-foot-high Hotel Manger opened in 1926, designed by H. Craig Severance, a name it held for a few years before adopting the Taft. Many rooms were packed into its Seventh Avenue locale, running the block from 50th to 51st Streets; estimates range from 1,250 to 2,000. The place has been divided in two, part a hotel and the rest apartment residences.

Following the 1929 success of his Hollywood Restaurant, Nils T. Granlund opened the Paradise Restaurant in 1930. He followed the same formula of no alcohol, mass-produced meals, and scantily clad women. The back of this 1930s card claimed the Paradise's dazzling floor shows, beautiful girls, and $1.50 dinner was New York's greatest show value. (Courtesy of Joan Kay.)

73

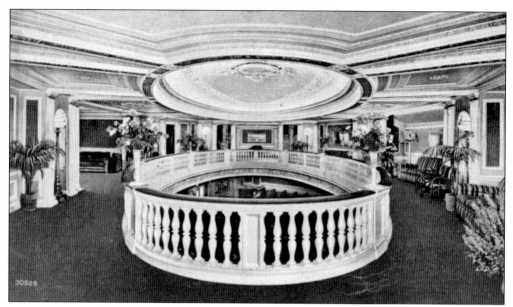

The Rivoli Theater at 1620 Broadway and 49th Street was built for the motion picture in 1917 and designed by Thomas W. Lamb. It was developed by master movie mogul S.L. "Roxy" Rothental, who elevated the state of the art as he moved from place to place, culminating in his namesake Roxy (p. 72). The richly decorated interior was changed over the years. The Rivoli was demolished in 1987.

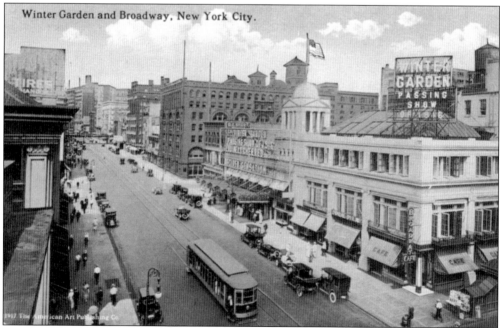

The Schuberts remodeled the former Horse Exchange into the 1,800-seat Winter Garden Theater in 1911. The building, spanning the short block between Broadway and Seventh Avenue, is seen looking north on Broadway from 50th Street. A reminder of the area's past was on the next block, the seven-story Healy & Company coach building factory.

Four

42ND STREET: THE HUDSON TO SEVENTH AVENUE

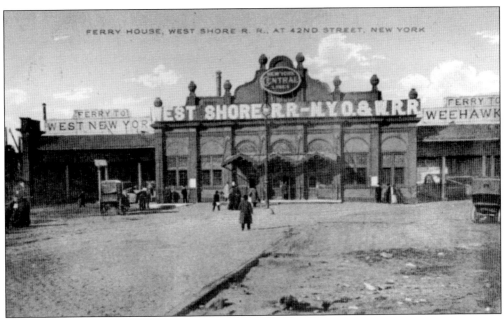

The New York Central's ferry pier and house stood at the western end of 42nd Street. The West Shore line began as a planned Pennsylvania Railroad competitor with the New York Central, but the latter acquired it. The New York, Ontario, & Western was an attempt to link the Lake Ontario part of Oswego with New York City, an ill-financed venture that also came under the Central's control. The two lines ended at West New York and Weehawken, their ferry links with 42nd Street running from 1902 to 1922 and 1884 to 1959, respectively. This spot on the water is now vacant. (Courtesy of Joan Kay.)

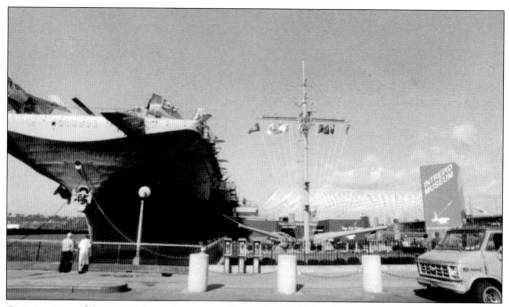

Construction of the USS *Intrepid* began on December 1, 1941; the completed ship saw extensive action in the war in the Pacific in 1944 and 1945. After a final service cruise in 1973, the *Intrepid* was placed in reserve in 1974 and stricken from the Naval Register in 1980. The Intrepid Museum Foundation acquired title in 1982, opening the Intrepid Sea Air Space Museum the next year. Moored in the Hudson River at Pier 86, the floating museum has expanded its exhibits in recent years. The ship, designated a National Historic Landmark in 1986, is pictured on a *c.* 1989 John Kowalak photographic card.

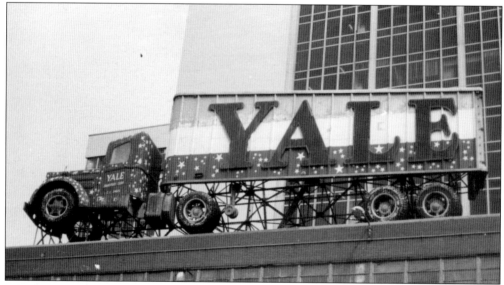

The Yale Transport sign, one of New York's most striking advertisements, is best viewed from the Hudson River, now that a close-up glimpse is no longer available from the former West Side Elevated Highway. Seen on a John Kowalak photographic card *c.* 1980 in bicentennial decor, the side of the tractor trailer currently stands on a vacant building, its paint largely peeled away. One of New York's great signs appears to be in its final struggle with the elements.

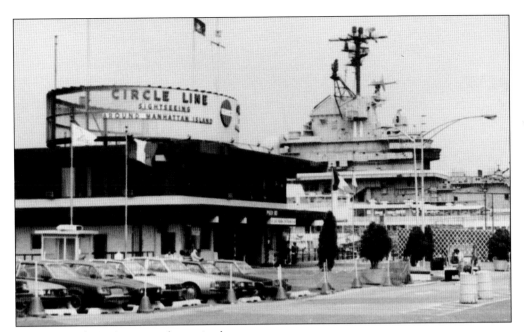

Excursion sails in city waters began in the early 19th century. Circle Lines was formed in 1945 by Francis J. Barry, who merged a number of formerly separate operators. Downtown boats run to Liberty and Ellis Islands; their 43rd Street pier is the origin for tours that circle Manhattan. The *Intrepid* is in the background of this 1989 John Kowalak photographic card.

The stem of 42nd Street west of Eighth Avenue was revitalized beginning with federally subsidized housing at Manhattan Plaza, completed in 1977. A later project, Riverbank West, is pictured *c.* 1989 by John Kowalak, under construction at the southeast corner of Eleventh Avenue.

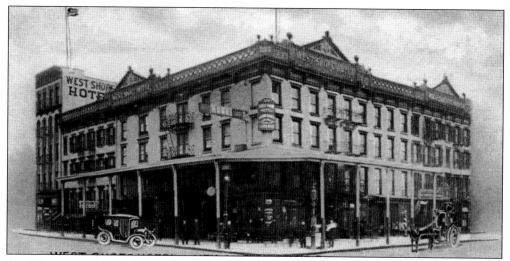

The West Shore Hotel, 568 West 42nd Street at the southeast corner of Eleventh Avenue, appears to have been built in at least two major sections. The likely older part on the corner may date from *c*. the 1860s, but smaller, lesser-known hostelries often escape the historical record. An L-shaped expansion enveloped the original. The hotel, as its name implies, was probably established to capture the maritime trade; the docks were only a block to the west. The back of the card had a printed advertisement for a Hudson-Fulton Celebration (1909) special rate promotion; single rooms began at 75¢. A FedEx World Service Center occupies the corner now.

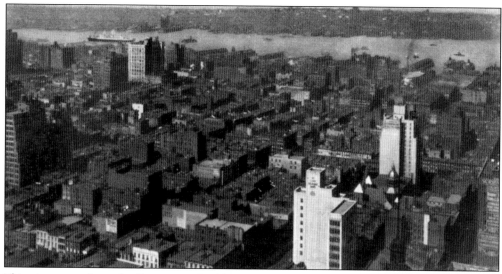

This view west from the Paramount Building is a microcosm of the rise and fall of the area, developed in the mid-19th century for fine brownstone residences by notable real estate figures, including William B. Astor. However, by the turn of the century, many had been converted to brothels, as sin also moved uptown. The displacement of this type of activity from its earlier locales by rising values and higher property use is a process that has recently driven sinful occupancies away from the Times Square region. The area around 43rd Street and Eighth Avenue, in the lower right corner, was primarily brothels in 1900. Forty-second Street runs to the left of the two tall buildings; the dome is Holy Cross (p. 81). The two blocks at the lower left are the site of the bus terminal and the McGraw-Hill Building.

The Port Authority of New York built this massive bus terminal between 1947 and 1950 (before New Jersey was added to its name). The terminal was designed Walter McQuade, chief of the Port Authority's engineering department. The facility, the largest of its type in the world, covered the block bordered by 40th and 41st Streets and Eighth and Ninth Avenues. The original organizational plan of the four-story terminal, clad in red brick and limestone, was to direct buses from the Lincoln Tunnel via ramp to upper levels, while long-distance buses, many of which did not use the tunnel, entered via the street. Its initial capacity, 2,500 buses per day and 450 cars in the rooftop parking lot, has been expanded, as was the structure. A major addition was built in 1981 on the north, replacing the half block containing the low-rise buildings west of Eighth Avenue, seen at the right on a c. 1951 monochrome. Ramps connecting old and new sections and their exterior steel support structure obscure the original Eighth-Avenue cladding. All bus companies moved in at the outset, except Greyhound, which joined in 1963.

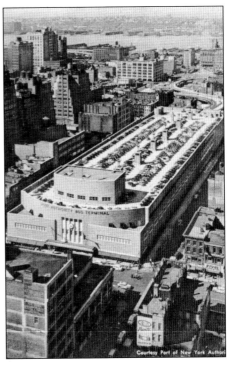

Courtesy Port of New York Authority

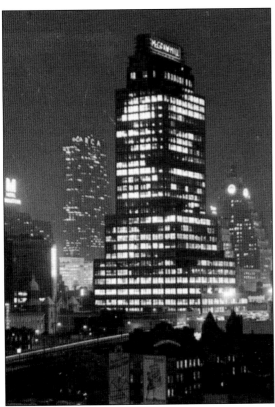

Raymond M. Hood gained sudden prominence when he won the 1922 competition (with John Mead Howells) to design the Chicago Tribune Building. His major work, however, became New York skyscrapers. The McGraw-Hill Building at 330 West 42nd Street, designed in conjunction with Godley & Fouilhoux, was an innovative design that ended use of the Gothic style for offices and paved the way for the International Style, which dominated office construction for more than three decades. The 36-story, 488-foot building, largely occupied by its builder for book production, made extensive application of color and expansive use of glass. The horizontal spandrels are blue-green; the while metal window frames and casings are blue-black, with vermilion strips. Its industrial design also employed innovative concrete encasing of its steel columns, reducing the number required and increasing available floor space. Controversial when new, the McGraw Hill Building was designated a New York City landmark in 1979.

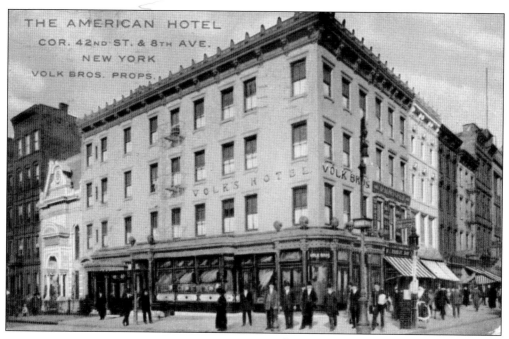

Volk's Hotel, also known as the American Hotel, stood on the northwest corner of Eighth Avenue, a site where nothing remains from this *c*. 1910 card. Today, the corner is filled by a tall, one-story brick building with a forbidding exterior.

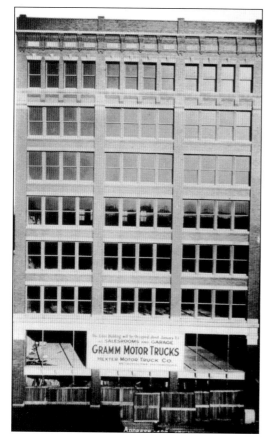

A new business building rising on the north side of 42nd, at mid-block between Ninth and Tenth Avenues, is pictured on a *c*. 1910 photographic card, announcing its occupant as a motor truck company. Interestingly, Gramm located not far from the traditional home of the automotive industry, Longacre Square. The site is still devoted to the industry, now as the parking garage opposite the northern end of Dyer Avenue. As those familiar with midtown congestion know, parking is a more lucrative use today than one more old industrial building. (Courtesy of Joan Kay.)

The 400-room Hotel Holland, built *c.* the 1920s at 351 West 42nd Street, was furnished with foldaway beds, turning sleeping quarters into daytime living rooms. Equipped with a swimming pool, gym (spa, in 21st-century speak), and handball court, the hotel permitted in-room cooking, making convenience its service differentiation. The little-changed building (the café is gone), pictured on a *c.* 1930s linen and a *c.* 1960 chrome, has been remodeled into efficiency apartments.

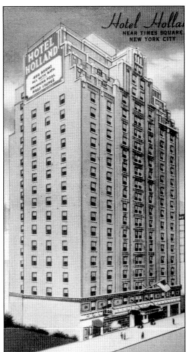

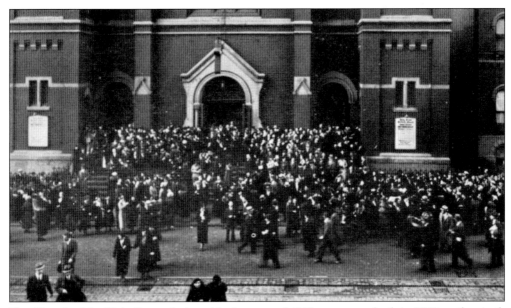

The Church of the Holy Cross, designed by Lawrence J. O'Connor, was built in 1870 on the north side of 42nd Street. Its early years were characterized by the transformation of its surroundings from a genteel residential district to the rough and tumble neighborhood known as Hell's Kitchen. The Reverend Francis P. Duffy, pastor from 1920 to 1932, is memorialized by the Times Square statue seen on page 38. The crowd pictured *c.* 1930s is gathered for a miraculous medal novena, referring to the religious sacramental struck through inspiration of a vision received by Catherine Labouré in 1830.

The New Amsterdam Theater at 214 West 42nd Street, designed by Herts and Tallant, opened on November 2, 1903, with a performance of *A Midsummer Night's Dream*. While serving the stage, it was considered the most attractive of Broadway theaters. Its interior was finished in a richly designed Art Nouveau style, new in New York at the time. The New Amsterdam, the largest theater at 1,800 seats when built and home to many hits, was adapted for films in 1937. A once-ornate exterior was marred for its marquee. The theater closed in the early 1980s. Its restoration was considered a key element of redeveloping the area. Pictured by John Kowalak when closed, the restored New Amsterdam has since reopened. The Candler Building at the right still stands, in need of the care extended to its neighbor on the east.

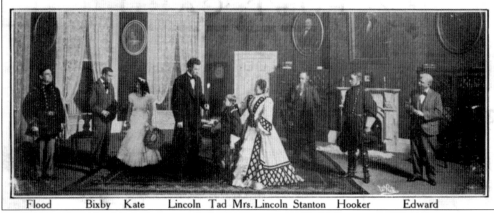

This drama of the Civil War era opened on March 26, 1906, at the Liberty Theater at 234 West 42nd Street. The house, later exhibiting films, merits historical note for its premiere nine years later of *Birth of a Nation*. (Collection of Karen L. Schnitzspahn.)

The Republic Theater, designed by McElfatrick & Company, opened in 1900 at 207 West 42nd Street. Built by Oscar Hammerstein I, it was leased to David Belasco, who renamed the theater for himself. The Republic became home to burlesque in 1931, but was forced to terminate that format after a city crackdown. It was renamed the Victory and began exhibiting films. The place closed, but its restoration became a second cornerstone in Times Square's redevelopment. It was redesignated the New Victory Theater, following an award-winning restoration by architects Hardy Holzman Pfeiffer Associates. The photographic card is by John Kowalak.

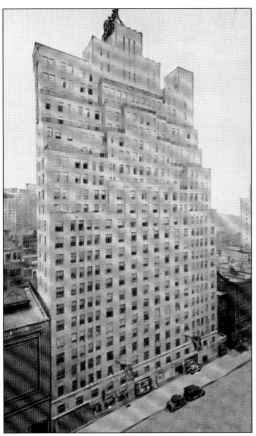

The Hotel Dixie used "address inflation" to list its place in the city as 251 West 42nd Street, having only an entrance there that passed through to the actual 43rd Street location. Designed by Emery Roth and completed in 1930, the 650-room hotel also had a garage that at times served as a bus station. The 43rd Street facade is pictured when new on a card that boasted on the back that each room was equipped with a radio that received three stations. The place is still in business and has been renamed the Hotel Carter.

83

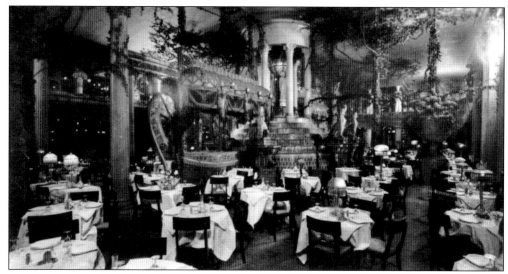

John L. Murray's *Roman Gardens*, which opened in 1908 on the south side of 42nd Street in mid-block between Seventh and Eighth Avenues, was the prime exemplar of using richly decorated, exotic interiors to attract fashionable diners. The place was reportedly modeled on a French castle and was filled with objects that might represent the best of Rome in the time of Caesar. Paintings and statuary were displayed throughout. This photographic card depicts the main dining hall when new.

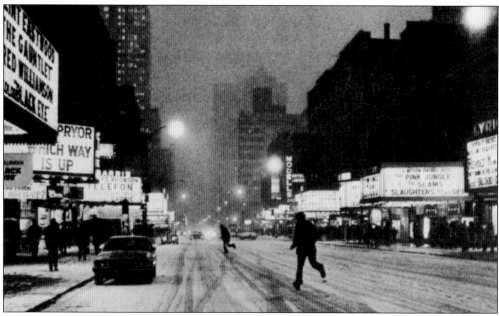

The block of 42nd Street from Seventh to Eighth Avenue, once home to fine legitimate theaters, declined over the years, becoming a street of dingy movie houses on the surface and den to every imaginable vice underneath it. Known as "the strip," its grime, looking particularly dismal in evening snow on a John Kowalak 1977 photographic card, has been cleaned up. Restorations, new construction, and a population change are turning the area's worst street into one of its brightest.

Five

42ND STREET: BROADWAY TO MADISON AVENUE

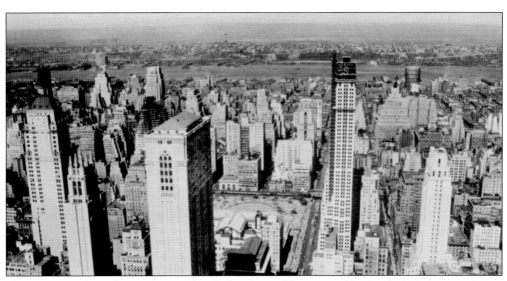

This view west from the newly completed Chrysler Building is readily dated 1930, the completion year of Chrysler and 500 Fifth Avenue, seen in the center in the final stages of construction. The Times Tower is at its right; the Bush Tower (p. 89) is the taller building to its right. This image of the Lincoln Building (p. 116) in the center foreground shows a good view of the fine Gothic window on the east side of the tower. The tall, narrow tower to the left of the Lincoln Building is the Lefcourt Colonial Building at 295 Madison Avenue, completed in 1929 to a design by Charles F. Moyer. The Lefcourt National Building, 521 Fifth Avenue at the northeast corner of 43rd Street (right) was designed by Shreve, Lamb, & Harmon and completed in 1928. The 48-story building at the far left is the 10 East 40th Building, located a few feet east of Fifth Avenue. The 632-foot-high building was completed in 1928.

DINE LEISURELY AND COMFORTABLY IN AIR-COOLED ATMOSPHERE

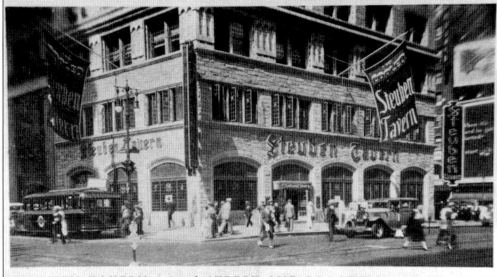

STEUBEN TAVERN · 42nd STREET AND BROADWAY · NEW YORK

The Heidelberg Building was an 11-story square tower on a 7-story office base, built *c.* 1911 on the south side of 42nd Street, the short block that spans Broadway and Seventh Avenue. The site was the former home of the Hotel Metropole, which served as a massive signboard in its later years, a role the tower was expected to emulate. Plans for the building were changed often, both before and after its grade-floor occupancy by the Steuben Tavern, seen here *c.* 1940. Later known as the Crossroads Building, the property was sold to the city in 1981.

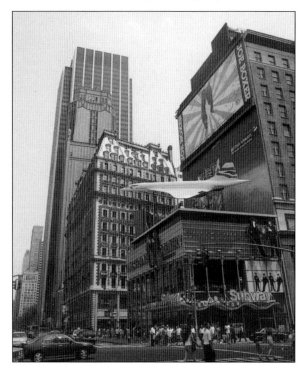

The Crossroads Building was demolished in 1984; the site was occupied for some years by trailers housing a tourist office and a tiny police station. This two-story building, occupied by the Times Square Brewery Restaurant, was built in the 1990s. The half-scale model of a British Airways Concorde, mounted on the roof in 1996, is pictured in front of the Knickerbocker Hotel on a contemporary chrome, issued by photographer-postcard publisher Gail Greig. The Bush Tower (p. 89) is above it; the office tower on the southwest corner of Sixth Avenue, built by New York Telephone in 1974, looms over both. The restaurant is a temporary space filler, of utility until long-held and evolving plans for a major office tower come to fruition.

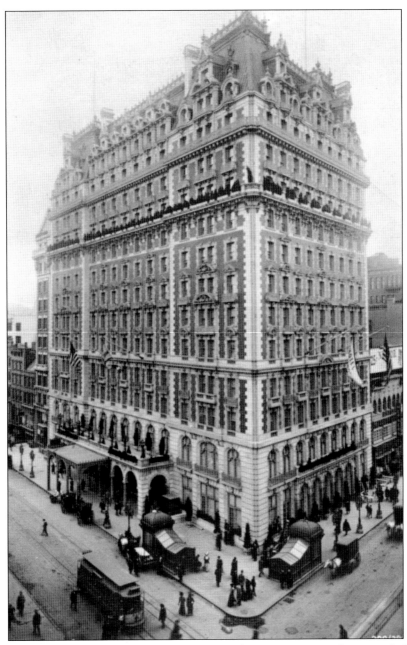

Construction of the Knickerbocker Hotel, designed by Bruce Price and Marvin & Davis, was halted in February 1904 by financing problems and was resumed in 1905 by John Jacob Astor IV, who hired Trowbridge & Livingston to redesign the interior. The Beaux Arts-style hotel on the southeast corner of Broadway and 42nd Street, the former site of the St. Cloud Hotel, showing the influence of the nearby Astor (p. 22) and opening in October 1906, was an immediate success due to its restaurants and artful decor. The place, remodeled as an office in 1920, was known as the Newsweek Building from 1940 to 1959. It was converted to residential lofts c. 1980 and later to garment trade showrooms, its present occupancy, along with street-level stores. Note the elaborate iron canopy shown on this c. 1908 photographic card.

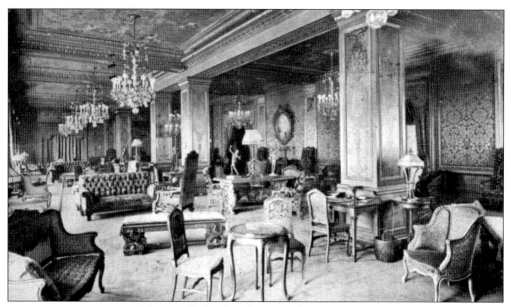

James B. Regan operated the Knickerbocker from 1906 until his 1920 retirement, a decision probably influenced by the onset of Prohibition. The 550-room hotel was driven by the three lower floors of dining and entertainment facilities. The Knickerbocker was not as expensively decorated as the nearby Astor, but this early image of its foyer suggests no lack of comfort. Nearly all traces of interior hotel design were removed in the 1920 office remodeling designed by architect Charles Platt.

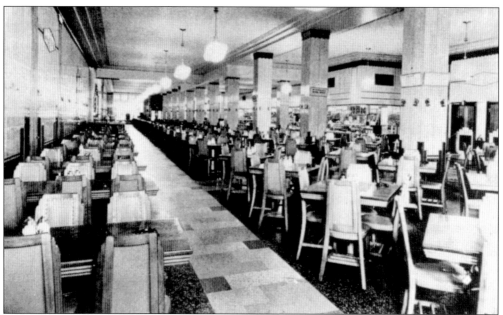

The former 42nd Street Cafeteria is typical of the utilitarian restaurants that fed large numbers of workers before the advent of fast-food places and salad-hot food bars. The 110 West 42nd Street establishment, near Sixth Avenue and running through to 41st Street, claimed to be the largest self-serve restaurant in the state, serving 10,000 people daily. (Courtesy of Charles Kleinman.)

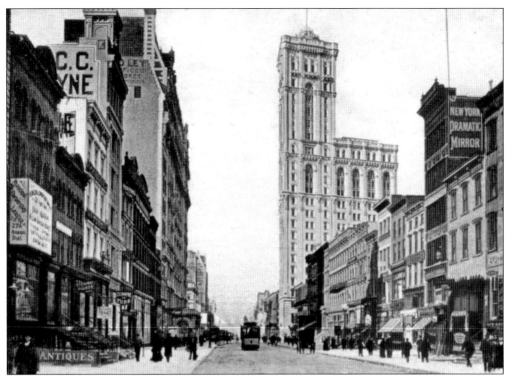

This *c.* 1906 card looking west from Sixth Avenue reflects an evolving 42nd Street. The new Times Tower was soon to have an office neighbor on its east side, the 1912 Longacre Building on the northeast corner of Broadway, the present site of the Condé Nast Building. The rest of the block, then primarily four- and five-story brownstones, were to be developed over the years with other structures, but that stem is now underutilized, being assembled for a proposed major office project. The Knickerbocker Hotel is the large presence at the left, while at the far left are the buildings replaced by the tower shown at the bottom of the page.

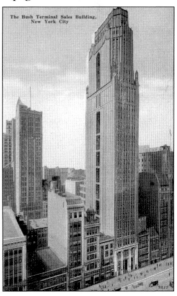

The 30-story, 430-foot Bush Terminal Sales Building, designed by Helmle & Corbett's Harvey Wiley Corbett to fill a 50-foot-wide, 90-foot-deep lot at 130 West 42nd Street, was erected in 1918 by Irving T. Bush as a home for sales displays. Bush was the developer of the namesake massive industrial terminal and port on the Brooklyn waterfront. The Neo-Gothic design was intended to be an artful model for mid-block construction, anticipating changing zoning and an evolving 42nd Street. The narrow dimensions emphasize the building's verticality; its top was designed to resemble a soaring cathedral tower. The building was promoted as the home of the International Buyers Club; the architect took an office on the top floor. The little-changed building, now known as the Bush Tower, maintains its graceful stature on a much-altered block. However, the Gothic entrance was removed to permit the addition of a store. The cupola on the since-removed building to the east is a link of this *c.* 1920 image to the one at top of the page.

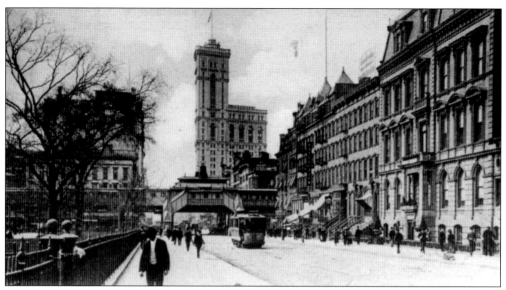

The built environment on the block east of Sixth Avenue and the image on the preceding page had a similar character, interjected by an occasional public building, such as the Harmonie Club, at the right and opposite. A wrought-iron fence surrounds Bryant Park at the left; the Harvard Building was behind the tree west of the avenue. The Sixth Avenue elevated, which ran from 1878 until 1938, was razed in 1939. So was the Park View Hotel, not long after this 1905 Rotograph card was published. (Courtesy of Neil Hayne.)

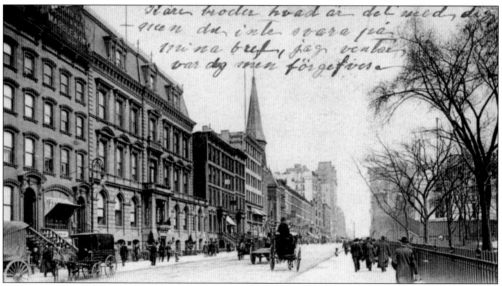

The Rotograph photographer had to move only a few feet to take this image of the same street shown at the top of this page looking east, with the Harmonie Club now on the left. The West Presbyterian Church, founded in 1829, erected this edifice in 1862, one that would soon be taken down for construction of the Aeolian Building. The eight-story structure above the low-rises is the Bristol Building on the northwest corner of Fifth Avenue; the Transit Building appears to be the tall one in the background. The public library, under construction at the time, can be seen beyond the trees at the right.

The Harmonie Club, an aristocratic German Jewish social club founded in 1852, built this clubhouse at 45 West 42nd Street c. the 1870s. The wing on the east was a later addition, and the entrance had earlier been one flight up to the main level above grade. The group maintained German as its official language and honored the liberal practice of permitting wives to attend with their husbands. Cognizant of the changing character of 42nd Street, the club moved to 4 East 60th Street in 1906, not long after this card was issued.

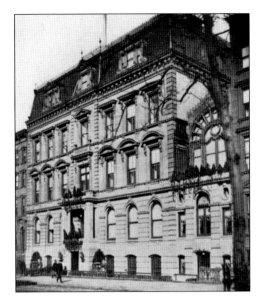

The Hippodrome opened in 1905 as the world's largest theater, seating 5,200 and occupying the full Sixth Avenue block from 43rd to 44th Street. Designed by J.H. Morgan, the showplace was built by Frederic Thompson and Elmer S. Dundy, two promoters who had earlier collaborated on the Coney Island amusement center, Luna Park. The Hippodrome's stage was an enormous 200 feet wide by 110 feet deep. The opening words posted over the entrance date this image as 1905, but the autos were inserted and the card was published later. Spectacular productions included dancing elephants and a huge water tank capable of every aquatic effect. The theater's appeal had faded by the 1930s, when a variety of nontheatrical productions filled out its final years. The place was demolished in 1939; the present office on the site was begun in 1952 and was expanded at least twice.

Bird's Eye View of 42nd Street from 6th Avenue, New York City.

This view east toward Fifth Avenue may have been taken from the Bush Tower not long after its 1918 completion. Fleishman's Baths filled the northeast corner of Sixth Avenue; the Stern's store is east of it, followed by the Aeolian Building. The structure over it is the Biltmore Hotel (p. 110), running the block from 43rd to 44th Streets on the west side of Vanderbilt Avenue.

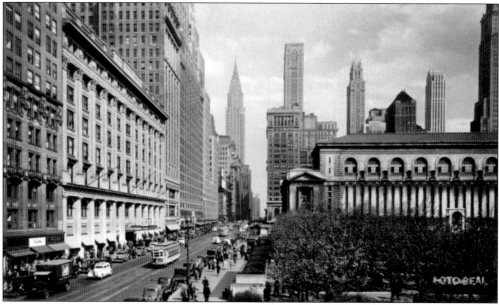

Stern's moved its department store from West 23rd Street to 42nd Street *c*. 1913. Its home opposite Bryant Park, designed by the firm of John B. Snook, is the most prominent building on this 1940s photographic card, looking east. Fleishman's Baths had been replaced by a substantial office on the northeast corner of Sixth Avenue. The Aeolian Building, adjacent to Stern's on the east, is better viewed on the next page; the Salmon Tower is east of it, a 32-story office completed in 1927, designed by York & Sawyer. That building is also seen at the top of page 99.

The tall building at the right, 33 West 42nd Street, was erected in 1912 as Aeolian Hall. Its third-floor concert hall had a noteworthy but short role in American musical life. Aeolian moved in 1926 to more elaborate quarters at Fifth Avenue and 54th Street. The building served as the City University Graduate Center from *c.* 1967, following a fine remodeling by architect Carl J. Petrilli that included an arcade providing a grade-level pass-through to 43rd Street. It is now the College of Optometry of the State University of New York. The 42nd Street trolley began a run in 1908 that endured until November 1946. Some believe its termination was the street's greatest cause of congestion, as the trolleys were replaced by a greater number of lower-capacity, exhaust-spewing buses. Proposals to restore 42nd Street trolley service have been voiced, with a slim to no chance of acceptance. The image is a *c.* 1920 white border card.

A colorful *c.* 1940 linen card depicts both the exterior and the interior of Topps, which claimed to be the longest and friendliest bar in Times Square. One suspects Topps might have fought to keep that designation. (Courtesy of Joan Kay.)

NEW YORK CRYSTAL PALACE, 1853 MUSEUM OF THE CITY OF NEW YORK

The Crystal Palace, site of America's first world's fair, was built in 1853 near the southwest corner of Fifth Avenue (in the shadow of the reservoir), designed by Georg J.B. Cartenstein and Charles Gildemeister. After the fair closed in November 1854, the building was leased for various events prior to its destruction by fire on October 3, 1858. The more than 300-foot-high Latting Observatory, located across the street, burned in a separate fire. The card, perhaps dating c. 1940, was made from a historical print by the Museum of the City of New York.

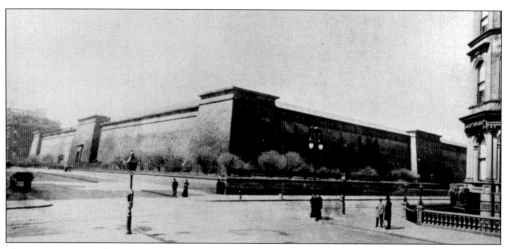

The Croton Aqueduct was a water supply system designed by engineer John B. Jarvis that pumped water 41 miles from north of the city through brick-encased iron pipes to storage sites in the city. The system, opening to great acclaim in 1842, included the fortresslike reservoir at the southwest corner of Fifth Avenue. After its abandonment by the 1890s, the land, part of the city's original common lands granted by the Crown under the Dongan Charter of 1686, was perceived as a fine site for a central library. However, enabling legislation from the state and approval of the city's board of aldermen were necessary to establish that the construction of a library was for the common good. The c. 1890s image predates the postcard era.

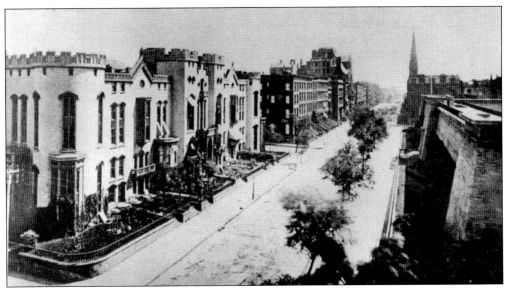

An 1880 view of the reservoir portrays the residential character of streets that were commercialized by the postcard era (pp. 85, 92, 99). The former Brick Presbyterian Church is in the background. The New York Public Library that later occupied the site at the right was organized in 1895 through the consolidation of the Astor and Lenox libraries and the Tilden Trust. The latter embraced the collection of former governor Samuel J. Tilden.

Carrere & Hastings's Beaux Arts design, intended to make the New York Public Library an outstanding monument, succeeded admirably. The cornerstone was laid in 1902, but construction encountered a series of delays and the library did not open until 1911. The design had to meet detailed organizational and operational criteria established by director John S. Billings. Pictured c. 1912 on a photographic card, the familiar, unchanged building is seen prior to installation of its sculpture.

STATUE IN FRONT OF NEW YORK LIBRARY, FIFTH AVENUE, NEW YORK

The enormous main reading room, nearly 300 feet long, pictured on a *c.* 1930 monochrome, has been a productive home to generations of intellectuals, writers, and members of the general public. After closing for an extensive restoration, which set everything aglow, the room reopened in 1998 with little physical change but subtle enhancements, such as computer wiring through the pedestals of the original reading lamps to address current technology needs. The room was renamed the Deborah, Jonathan, F.P., Samuel Priest, and Adam Raphael Rose Main Reading Room.

Sculpture missing from the bottom of page 95 includes the six figures over the central pavilion, by Paul W. Bartlett, and groups in the end pediments, by George Gary Barnard. Two figures called and representing *Truth* and *Beauty,* sculpted by Frederick MacMonnies, were placed in niches behind fountains on both sides of the entrances. Over *Beauty*, seen on a *c.* 1940 monochrome, is the carved inscription: Beauty/Old Yet Ever New/Eternal Voice/And Inward Word. *Beauty* stands south of the doors; *Truth*, the figure of an elderly man, stands to the north of them. (Courtesy of Moe Cuocci.)

The lions by Edward Clark Potter at the
Fifth Avenue entrance to the library may be
the most widely recognized and popular
sculpture on the island of Manhattan.

Bryant Park and the library make 40th
Street the practical south side of 42nd
for the block between Fifth and Sixth
Avenues. Its most noteworthy structure is
the landmark American Radiator Building,
at the center and on page 98. The 1907
Engineers Club is to its left, while at far left
is the 22-story, 265-foot building at 10 West
40th Street, built in 1915 to Starrett & Van
Vleck's design. The 1929 replacement of
the building, with the triangular gable left
of the Engineers Club, can be seen on the
top of page 98. The roughly *c.* 1925 white
border rendering shows one of the library's
pediment sculpture groups and the south
fountain sculpture.

The back of this white border card describes Raymond Hood's 1924 American Radiator Building as a "magnificent architectural interpretation of heat." This feeling was obtained by using gold-colored masonry to decorate the top of the black brick, 24-story, 337-foot tower. Located at 40 West 40th Street, in a mid-block plot opposite Bryant Park, the office is an early work of the young architect, who had been catapulted into prominence by winning (with John Mead Howells) the well-publicized competition to design the Chicago Tribune's new tower. The latter building is a readily recognizable design antecedent of the New York work, which has been described as having strong Gothic influence in its tower and fine bronze and marble entry, but also anticipating the Art Deco. Recently undergoing remodeling as a hotel, the building was floodlit at night, which enhanced its colors, giving the impression of glowing embers in a black iron furnace. The Scientific American Building is at the far left, the 1929 work of Ely Jacques Kahn, standing at 19 floors and 264 feet.

The Hotel Bristol (left background) was described in the 1893 *Kings Handbook* as well situated, an aristocratic and elegant house. The open vista left by the construction of the library setback from the sidewalk, made the hotel's roof appealing as a site for signs by the *c.* 1918 date of this card. The card's back pointed out that Fifth Avenue north from 40th Street, once the center of fashion, was then a congested retail district. The building on the northeast corner under the Diamo sign was the home of former vice president and New York governor Levi P. Morton. Its later commercial uses included hotel, retail, and tearoom occupancies. The building was demolished in the late 1990s, as a site for a major office building was being assembled. The minarets belonged to the Temple Emanu-El, which moved up the avenue to 65th Street in 1927. Note that the signs are on the 42nd Street side; the Fifth Avenue Association was strongly opposed to signs on that prestigious thoroughfare.

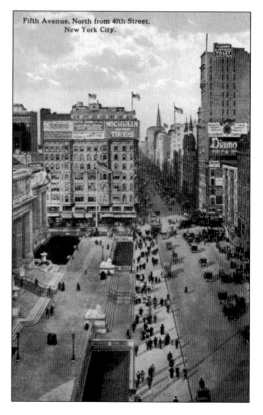

Fifth Avenue, North from 40th Street, New York City.

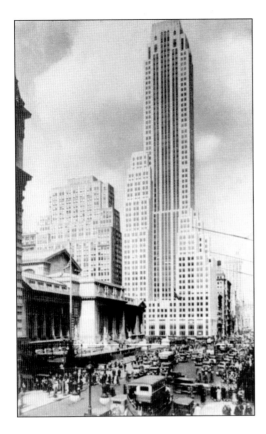

The Transportation Building, 500 Fifth Avenue, was built on the northwest corner of Fifth and 42nd Street and completed in 1930. Its architects were Shreve, Lamb, & Harmon, a firm that also designed the Empire State Building, which was completed the next year, eight blocks to the south. The 42nd Street building, "only" 697 feet and 60 stories, was named for its principal tenancy, the local office of most of the nation's major railroads. The construction had to fit a small lot under the constraints of the 1916 zoning regulation, accounting for the narrow tower. The Salmon Tower is adjacent; its base is visible on the bottom of page 92.

The Astor Trust Building was completed at the southeast corner of Fifth Avenue in 1917, designed by Montague Flagg. Today, it stands with its entrance moved to the southern corner of the lot to accommodate a street-level store. In New York, a 50-foot lot contains ample room for a 34-story building, which now occupies the spot at the right, 489 Fifth Avenue.(Well, somehow it fits.) Recently, the Carbide and Carbon Building at the left, 308 Madison Avenue, appeared to be in the process of being cleared. The buildings in between are interesting, particularly the row of five low-rises of varying ages and styles. However, their distinctiveness is marred by contemporary storefronts. The card is a c. early-1920s white border.

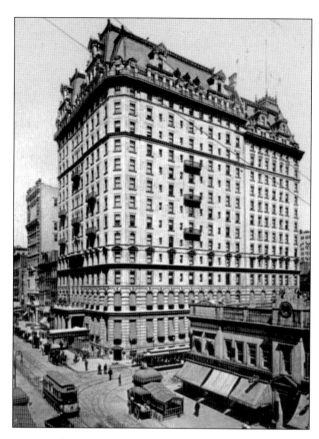

The 16-story Hotel Manhattan was built on the northwest corner of Madison Avenue. Completed in 1897, it was designed by Henry J. Hardenbergh. Its siting was a block west of Grand Central Terminal, which was propelling growth on eastern 42nd Street. The stores at the right, west of the terminal, were typical of the area prior to development. The hotel building was remodeled as offices in 1921, but was demolished and replaced c. the 1950s by the glass and steel office tower now on the site.

The Hotel Manhattan's interior was richly finished and made extensive use of dark wood. However, its business for social functions could not match other fashionable hotels, notably another Hardenbergh commission, the Plaza on Fifth Avenue. In addition, other new hotels in the Grand Central area strained the Manhattan's ability to maintain profitability.

The Hotel Manhattan (right) denotes this *c.* 1907 view east as taken from Madison Avenue. The tall structure to its left is the Transit Building at 17 East 42nd Street, designed by Charles A. Rich and built *c.* 1902. The flag in the center is atop the Hotel Bristol (p. 98); the block to its west is depicted in the same state, prior to the development that followed in the 1910 period, on page 90.

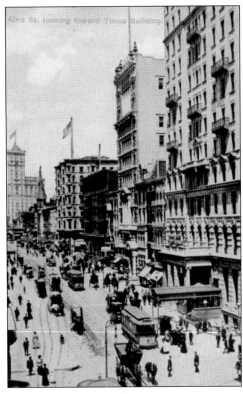

The Hotel Albany at the southeast corner of Broadway and 41st Street appears to date from the 1890s. It was expanded at least once, probably *c.* 1905, at the time of great growth in the area, at the rear on 41st Street, and perhaps a second time on Broadway. It is pictured both *c.* 1910 and about ten years later, when it was known as the Continental. Note the window and cornice changes in the Broadway building at the right. A brick high-rise garment industry tower is now on the site.

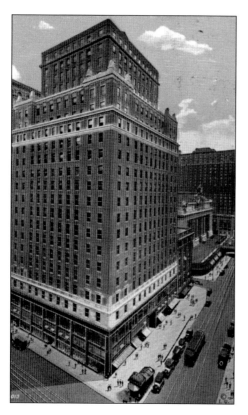

The 22-story, 313-foot-tall Liggett Building was erected in 1921 on the northeast corner of Madison Avenue, on the site of the stores that are visible on the top of page 100. Designed by Thomas Hastings of Carrere & Hastings, the red brick and limestone office was an early post-World War I tall building interpretation of the 1916 zoning regulation. The design embodies a 15-story base, a two-story setback zone, and a freestanding five-story pavilion. The building contained one of the largest Liggett Drugstores in that chain. It stands little changed, the top difficult to view in closely packed city streets.

Grand Central Terminal actively propelled office growth on Madison Avenue, which enjoyed a post-World War I boom. The Canadian Pacific Building at 342 Madison Avenue, spanning the block between 43rd and 44th Streets, was completed in 1922, designed by Starrett & Van Vleck. The plain exterior, described as having a "purely utilitarian character," was given an unusual and appealing distinction on 43rd Street, the entrance to the Fifth Church of Christ, Scientist (designed by A.D. Pickerill). Its tall Ionic columns are still a stately presence on the street. This white border card shows the southwest corner of 44th Street, the site of the former St. Bartholomew's Church, a perspective perhaps influenced by the desire to illustrate only one of the two Madison Avenue holdout buildings this office was built around, the four-story structure at the left. The two buildings were later remodeled and incorporated at each floor level into 342. Take a look at the site, as the cutout in what would have been a rectangular exterior is plainly visible, but the urban eye does not often focus above grade.

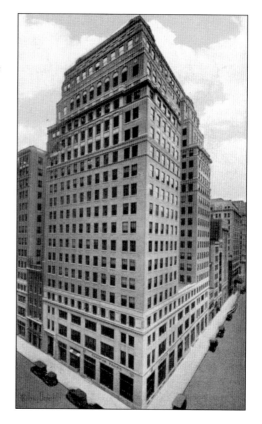

Six

THE GRAND CENTRAL AREA

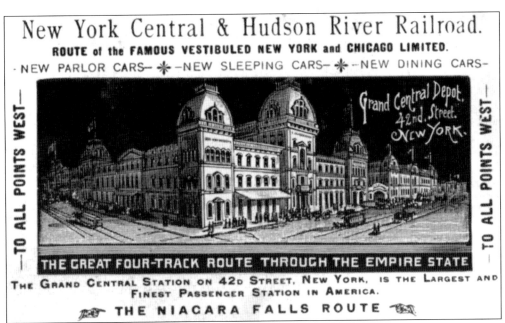

Operating steam locomotives down the length of Manhattan proved to be a dirty, smelly, dangerous process that the city sought to control in 1857 by banning train travel south of 42nd Street. Horse-pulled cars afterward took travelers south to the depot at Union Square, which was opened by the Harlem Railroad in 1831; this was impracticable. Cornelius Vanderbilt addressed the problem in 1869–1871 by building New York's first significant railroad station, designed by John B. Snook. The three towers on the 42nd Street facade reflected a division of services for three separate Vanderbilt-owned lines. The image is from a passenger agent's card.

The completed complex was immense, covering some 37 acres and including a head house, train shed, track and platform system, coach yard, and engine terminals. The rail yard north of the depot was 30 tracks wide and one-half mile long. An iron train shed spanning 17 tracks seemed then to contemplate unlimited growth. Despite the size of the facility and the impressive Second Empire-style station structure, the terminal, north of principal activity in the city, was by no stretch "central" and, according to some observers, not "grand" either. The photographic card appears to have been made by a traveler who printed his picture on postcard stock.

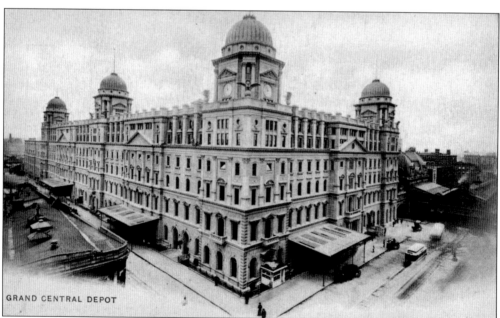

GRAND CENTRAL DEPOT

Success and traffic soon overwhelmed the 1871 station, which was expanded in 1898 to this six-story Renaissance design of stucco and artificial stone, by architect Bradford Lee Gilbert. A single waiting room was built in 1900 to remedy internal traffic problems. Note the eagles on the corner towers, which were dispersed in the station's rebuilding. One of the 1.5-ton birds was located and returned to the station and installed in 1999 at the entrance to an indoor food market.

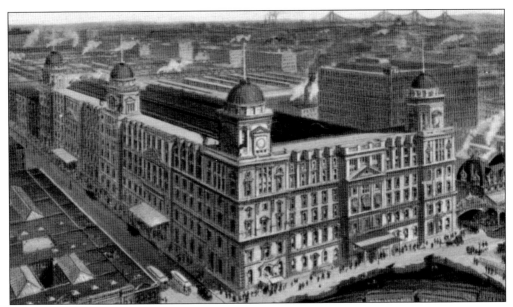

A deadly 1902 collision in a smoky tunnel resulted in the requirement that the line be electrified by 1908. The costly process was paid for, in part, by the railroad's developing of the land over its tracks, which were covered in the process. This is the origin of the modern Park Avenue; some of its course is seen in the background of this *c.* 1905 Illustrated Postal Card Company image. Note the old Grand Central Palace (p. 117) over the tower at the right.

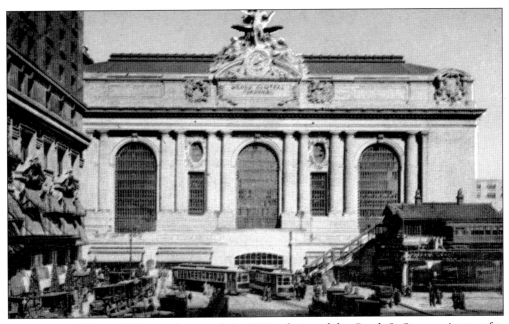

A new Grand Central Terminal opened in 1913, designed by Reed & Stern, winner of a competition, and Whitney Warren of Warren & Wetmore, cousin of New York Central chairman William K. Vanderbilt. The magnificent Beaux Arts-design facility, covering 69 acres, was the costliest rail station in the world. It is pictured when new, prior to the erection of the vehicle viaduct.

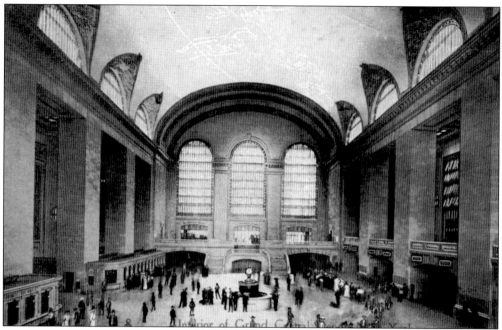

The new Grand Central contained 6 acres of waiting rooms, including a 275-foot-long, 120-foot-wide main concourse, seen looking west to the grand staircase leading to Vanderbilt Avenue. The 125-foot-high ceiling (higher that the nave at the Cathedral of Notre Dame in Paris) was decorated with a painting of the celestial bodies by Paul Helleu, the *Sky Ceiling*. This *c.* 1915 card presents an interior not seen in the recent past in the much-altered concourse, until revealed after a massive restoration was completed in 1998.

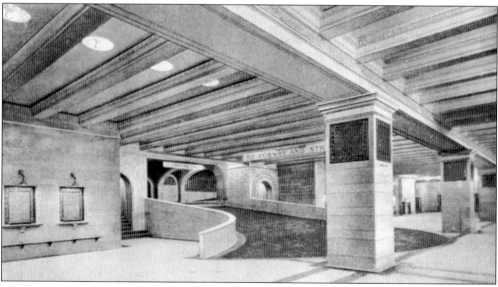

A key to the working of the new station was the separation of long-distance trains and local commuter, or suburban, lines. Its plan and much of the engineering of the electrification project was designed by William J. Wilgus, the New York Central's chief engineer. The entrance to the suburban concourse is seen on a *c.* 1915 Detroit Publishing card. (Courtesy of Barbara J. Booz.)

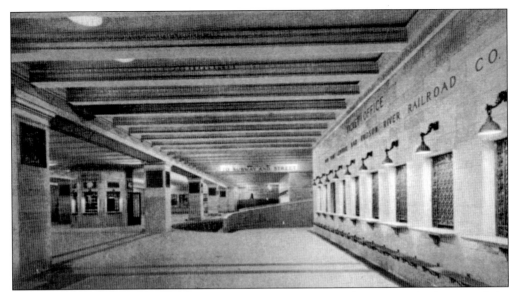

The suburban concourse is pictured on a companion card to the one on the bottom of the preceding page. William J. Wilgus also conceived the development of the land above the tracks. The planning of Terminal City included compatible offices and hotels that would be connected to the rail terminal; many are pictured in this chapter. Much of the station's grandeur was lost in grime and modifications. A $200-million restoration by the New York architectural firm Beyer Blinder Belle was completed in 1998; the terminal was rededicated on October 1, 1998.

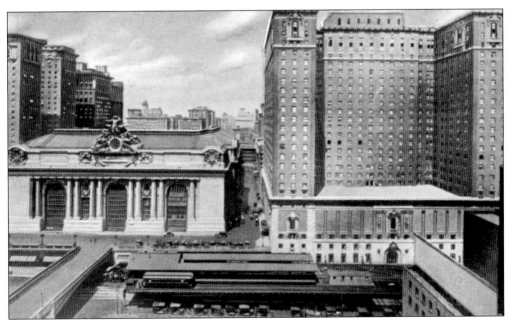

The Park Avenue viaduct opened in 1919, changing the street's character from congestion to fast-flowing highway. It is pictured *c.* 1920 with the Third Avenue Elevated spur present; the spur was torn down in 1923. The Commodore Hotel (p. 108), at the left, had a door opening to this roadway. The open space in the foreground indicates the Pershing Square Building (p.113) had not yet been constructed.

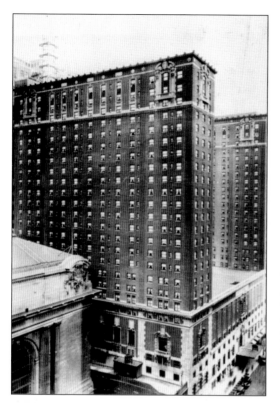

The Hotel Commodore, New York's largest, was designed by Warren & Wetmore and completed in 1913 as part of the new Grand Central Terminal project. It was a huge 28-story building, built on an H-plan, and contained nearly 2,000 guest rooms. Its many public facilities, including a banquet and ballroom, which was claimed *c.* 1930 to be the largest in the United States, established its principal role as a convention and business center, a place respected, rather than endeared in the hearts of New Yorkers. While the ballroom, which seated over 3,500, made the "Big Night at the Commodore" a byword in the event and affair industry, the place also offered a popular afternoon tea. The Commodore was torn down to its steel skeleton in the 1970s and rebuilt as the glass-enclosed Grand Hyatt, opening *c.* 1980. The foreground of this 1930s photographic card shows the entrance opening to the viaduct.

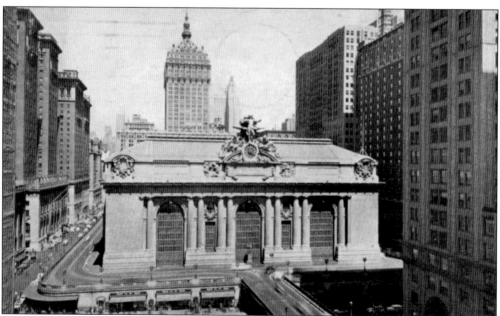

Park Avenue viaduct traffic exits through the New York Central Building, seen above the terminal in this 1930s card through arched openings, which are shown on the top of the next page. Sculpture is integral to the design of Grand Central, notably the monumental statues of Minerva, Mercury, and Hercules surrounding the clock on the 42nd Street facade.

The New York Central Building, designed by Warren & Wetmore and completed in 1924 at 230 Park Avenue, was the key office component of the Terminal City plan. The 40-floor, 566-foot structure dwarfed its Park Avenue neighbors (a fact perhaps lost in the photographer's close-in perspective), and its visibility for the block provided a reminder that the then mighty New York Central towered over its Grand Central dominion. The building's erection on stilts over two levels of railroad was a considerable engineering feat; special insulation protects the structure from railroad vibrations. The two arches are automotive passageways; the southerly side of the elevated is viewed below and on pages 107 and 112. The mid-rise brick buildings in this early-1930s photographic card reflected the planned character of Park Avenue for the surrounding blocks north, a series of buildings of similar height, but 250 Park Avenue, at the right, is the only reminder. A spate of high-rise glass towers in recent decades has diminished the former commanding presence of the New York Central Building. The building, restored in the late 1990s, had been known by other names in the recent past, but its original name now appears on the facade.

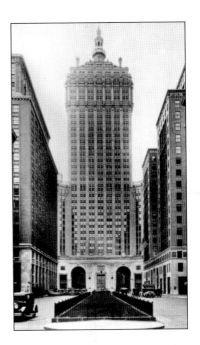

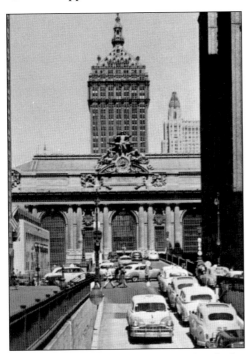

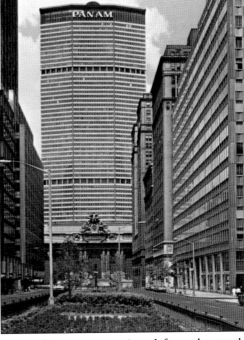

The New York Central Building also had a commanding presence viewed from the south, providing a cap over Grand Central Terminal. The loss of that vista was only one of the objections to the erection of the never popular 58-story Pan Am Building (now Met Life), designed by Emery Roth & Sons. It was the largest private office building in the world at 2.4 million square feet when completed in 1963, and overwhelmed its 3.5-acre site. The two chrome cards permit the viewer to be the judge.

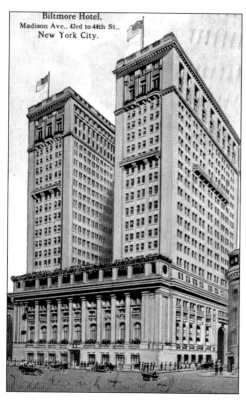

Biltmore Hotel.
Madison Ave., 43rd to 44th St.,
New York City.

The Neo-Classical 321-foot Biltmore Hotel opened on January 1, 1914, a work of Warren & Wetmore, located on the west side of Vanderbilt Avenue between 43rd and 44th Streets. Built over Grand Central's tracks, the 1,000-room hotel was complexly planned and integrated with the railroad. Travel-oriented basements, which included waiting rooms, train platforms, and a pedestrian concourse, required service facilities to be located above grade in the seven-story base, which also housed shops, lobbies, and restaurants. A deep light court formed a U-shaped plan for the guest room and banquet floors.

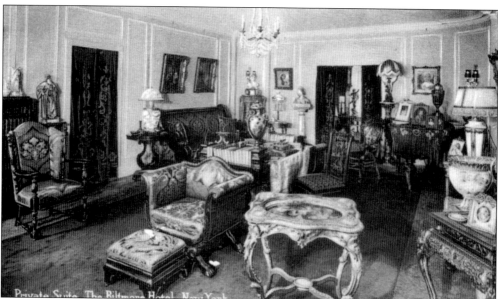

The origin of *Biltmore* means the manor house of Bilt, or the Dutch town from where the family's progenitor, Jan Aertsen van der Bilt, came. Integration with the station was a key operational element in an era of rail travel, when guests, including the well known and prominent, could arrive and be whisked by elevator from the arrival area to a private suite, while hardly being noticed.

110

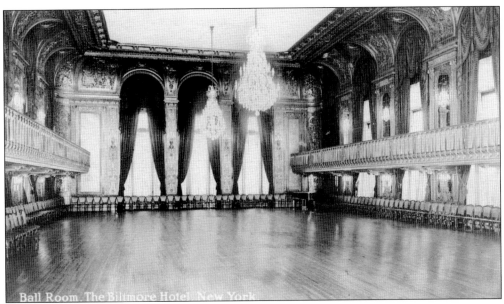

Ball Room, The Biltmore Hotel, New York

Biltmore's two-story ballroom was located on the twenty-second floor. The hotel was a popular meeting place, notably under the clock in the ornate lobby, and endeared itself to generations of New Yorkers. The Biltmore, closing in 1981, was the subject of a vigorous preservation campaign but was rebuilt as an office tower in 1983.

Graybar Building, 43rd Street, New York City.

The cavernous Graybar Building was a city within Terminal City, containing more than one million square feet of rentable space—in area, the largest office in the world when completed in 1927. The size is not suggested by this *c.* 1930 card of its east facade at 420 Lexington Avenue, but the aerial on page 120 (to the left of the Chrysler Building) depicts a deep lot totaling over 1.5 acres of ground space. The 33-floor, 400-foot-high building was designed by Sloan & Robertson and built by Todd-Robinson, whose principal, John R. Todd, later became adviser to John D. Rockefeller Jr. for the Rockefeller Center project. The Graybar Building was integrated into its surrounding properties. The entrance at the left led to a wide corridor running the full depth of the building and into Grand Central, while the basements were integrated with terminal operations. The ground floor connected with the Grand Central Station post office on the north. Indeed, the convenient access to Grand Central facilities was promoted as a leasing feature.

111

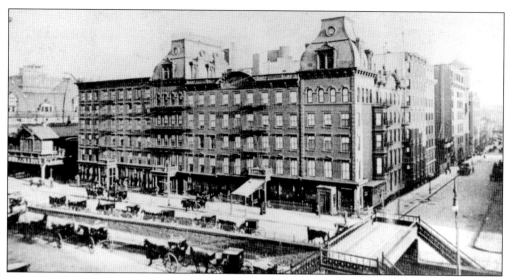

The Grand Union Hotel was begun in 1872 and designed by Edward Schott. Erected at the southeast corner of Park Avenue, the hotel ran the full block to 41st Street (right). The 200- by 135-foot hotel, containing over 350 sleeping rooms, one of the city's largest, grew with traffic from the railroad station across the street. Management claimed in the 1890s to have retained its popularity despite the presence of newer hotels; however, the obsolete hotel, perhaps better known then for its bar, was demolished in 1914 for subway construction. Note the railroad cut in the foreground and the mansard towers, stylistically harmonious with the early Grand Central.

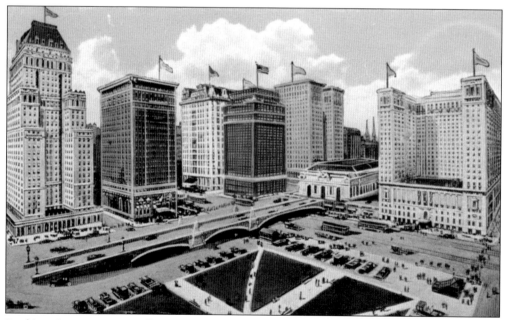

Pershing Square was actually a square, but only briefly, and probably unintentionally as the foundations for its namesake office building were laid c. 1914. The crude white border card contains an artist's rendition of surrounding buildings, including one never built, a projected New Murray Hill Hotel at the left. The four to its right are the Belmont (p. 114), Manhattan (p. 100), Liggett (p. 102) and Biltmore (p. 110). The Commodore is at the right and on page 108.

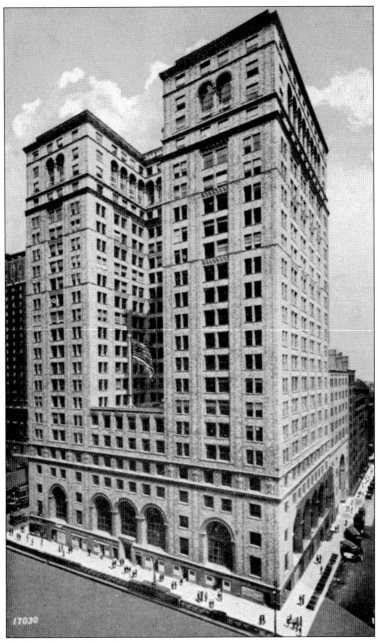

Foundations for the Pershing Square Building, named for the square which was named for the World War I general, were laid not long after the 1914 demolition of the Grand Union Hotel, but construction was delayed for interpretation of the evolving 1916 zoning regulation and then the war. The 23-story, 293-foot building, designed by York & Sawyer and completed in 1923 at 100 East 42nd Street, the southeast corner of Park Avenue, was the last major pre-World War II office built without setbacks. Following its original plans, a deep light court was designed from the eighth story. The building stands on the former square, its exterior little changed. A sign on the viaduct structure still designates this stem of Park Avenue "Pershing Square," but in a city where a building does not need a plaza to be named one, why should a "square" need a square?

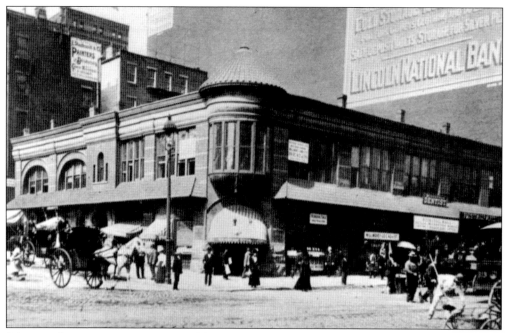

Schoonmaker's Drugstore was one of the retail-office occupancies on the southwest corner with Park Avenue prior to the erection of the Hotel Belmont. Seen in a late-19th-century view from *Valentine's Manual of 1916,* the hotel took the remainder of the Park Avenue block to 41st Street, including the site of the five-story building at the left in this image.

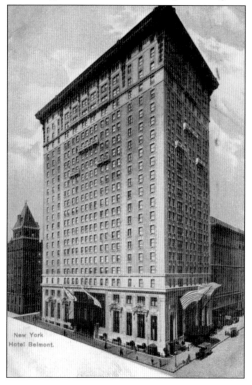

The Hotel Belmont was the tallest building on the east side when completed in 1906 at 292 feet and 21 stories, plus another five stories below ground. It is seen on a *c.* 1910 card with the Lincoln National Bank at the right and the Murray Hill Hotel at the left. Many hotels of the time were built for a 35-year life span. The Belmont closed in May 1930, prior to the end of its normal life expectancy, and was demolished the next year.

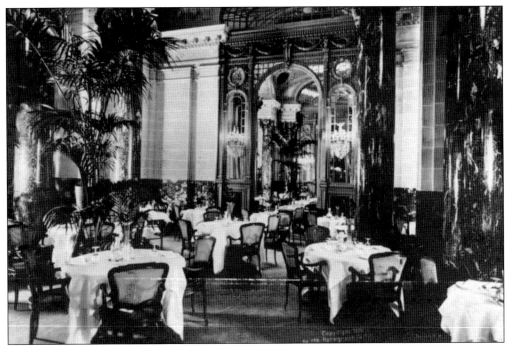

The Belmont enjoyed the reputation for the most lavish interior of the Grand Central vicinity hotels, a stature reflected in their elaborate palm garden. The place, furnished by W. & J. Sloane, had a ladies' vestibule on the Park Avenue side.

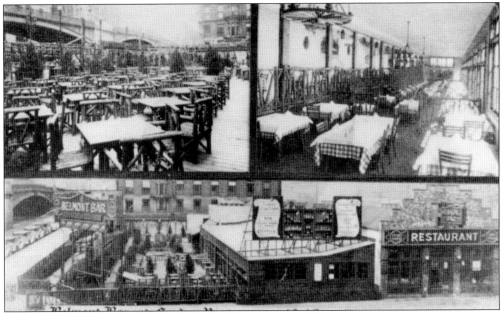

The Belmont Bar and Garden Restaurant was built on the hotel's site in 1933. The back of this Lumitone card claimed it was "the most famous eating place in New York." Perhaps its notoriety was attained as the world's largest beer bar and outdoor beer garden. It lasted to *c.* 1940, when the Airlines Terminal (p. 117) was built. (Courtesy of Melvin & Lillian Levinson.)

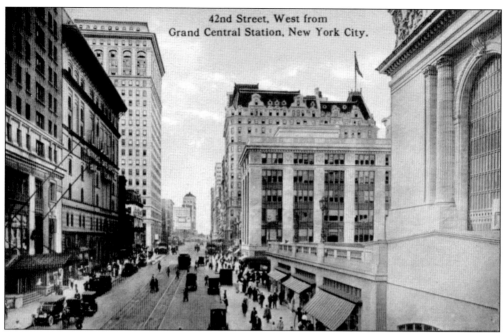

42nd Street, West from
Grand Central Station, New York City.

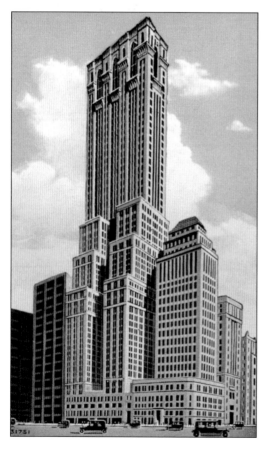

Partial views of Grand Central Terminal and the Hotel Belmont are on the right and left, respectively, of this c. 1915 view west. The 1882–1883 Lincoln National Bank, designed by John B. Snook, adjacent to the hotel, had bank offices on the grade level and household storage facilities on most of the above-grade floors. An additional 11 stories were added to the office on the northwest corner of Vanderbilt (next to Grand Central). The Hotel Manhattan (with the flag) is above it, and 308 Madison Avenue, at the southwest corner, towers over Lincoln. Interior offices were originally designed to accommodate many small tenants. However, the building recently underwent a major interior reconfiguration for larger offices, to meet contemporary leasing patterns.

The 54-story, 680-foot Lincoln Building at 60 East 42nd Street was completed in 1930, designed by J.E.R.Carpenter. The base, rising in three stages, is topped by a wide tower. The building, of massive scale, contains nearly one million square feet of rental space. The card is a crudely drawn white border, accurately representing the Lincoln, but not the Hotel Belmont to its left.

116

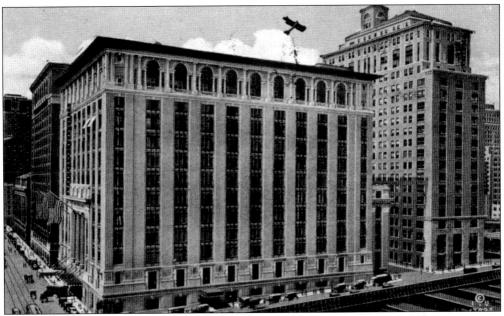

Grand Central Palace at 480 Lexington Avenue, between 46th and 47th Streets, was New York's principal exhibition hall prior to the 1956 opening of the Coliseum. It was designed by Warren & Wetmore and built in 1911 to replace an earlier Palace on the 43rd–44th Street block (p. 105), which was destroyed in Grand Central's expansion. The Palace was said to accommodate as many as 50,000 visitors at one time. At the left on this 1920s white border card is 466 Lexington Avenue, a former New York Central office, and the Grand Central Station post office south of it. The Park-Lexington Building at 247 Park Avenue, a 21-story, 271-foot Warren & Wetmore design completed in 1923, is at the right.

The Grand Central Palace contained a number of permanent exhibitions, and its tenth floor contained Grantland Rice's golf course, the finest indoor links anywhere. This white border card, labeled "Dancing Carnival," has not been positively identified with the Palace's sixth floor "Clover Gardens," claimed to have been the largest and most magnificent dancing hall in the country. The superlatives come from the 1932 *New York The Wonder City*, the period's most exuberant in-print promoter of New York.

The Art Moderne-style Airlines Terminal Building, designed by John B. Peterkin and completed in 1940 on the site of the Hotel Belmont, was described as an air age counterpart of Grand Central. It served reservation, ticketing, and baggage functions for major airlines, and as a source for airport ground transport. The building was demolished in 1977 for the erection of the Philip Morris Building, the office tower now on the site. The *c.* 1885 Murray Hill Hotel is behind it, while adjacent to the west is the Lincoln Building (p. 116). (Courtesy of Neil Hayne.)

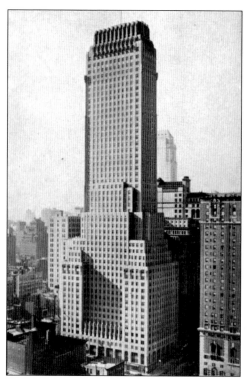

Irwin Chanin entered the construction business in 1919 and within ten years Chanin Brothers real estate and building interests owned 141 buildings. Their 56-story, 680-foot office headquarters at 122 East 42nd Street, the first skyscraper around Grand Central, replaced a storage warehouse and was the third tallest in the city when completed in 1929. The building then also contained the highest elevators in New York. That ranking was soon eclipsed in the period's construction boom. Designed by Sloan & Robertson, the buff brick and terra-cotta-clad building, facing Lexington Avenue, had a U-shaped base in a plan evolving from complex zoning requirements. The recessed four-story crown, accented with buttresses, produced dramatic effects when illuminated at night. The landmark office, seen on a *c.* 1940 Lumitone card, stands unchanged.

The Chanin Building made the symbolic statement its builder expected. The erection of the Chrysler Building in 1931 at 405 Lexington Avenue, running the block from 42nd to 43rd Streets, and its builder's goal of symbolic significance, resulted in its construction becoming veiled in secrecy in what became the great skyscraper race. The two buildings are seen in an early-1930s photographic card looking east, with a portion of the Commodore Hotel in the foreground and the southern end of Roosevelt Island visible at rear. A syndicate erecting 40 Wall Street announced its plan to build the tallest building in the world, a distinction Walter Chrysler coveted. (continued)

William Van Alen's initial plans for the Chrysler Building would have fallen short of the competition's 70-story, 927-foot downtown project. Avoiding a public announcement that might have caused the builders of 40 Wall Street to raise its projected height, the Chrysler Building's contractor, Fred T. Ley, assembled a tower in secrecy inside the incomplete building, raising the tower through the roof to reach 1,046 feet. Alas, the tallest title would be eclipsed by the Empire State Building a few months later. St. Agnes Roman Catholic Church, at the right, was destroyed by fire in 1992. At the left is the cavernous Graybar Building (p. 111). Grand Central Palace (p. 117) surrounds the spire.

Seven

42ND STREET: EASTERN STEM TO THE UNITED NATIONS

This view east on a *c.* 1935 photographic card from the Chrysler Building was ostensibly taken from its tower; if so, the top of the 39-story News Building at the right appears too close. A well-known amenity of buildings facing east near the East River is the view across that body. However, many buildings erected in the first half of the 20th century, notably Tudor City (p. 125) had few windows facing what was then a grimy industrial area (p. 126). That development, the high rises in the center of this image, is a 1925–1928 project by Fred F. French that was conceived to make city living affordable and near the booming office market in the Grand Central area. Tudor City includes the mid-rise buildings perpendicular to the structure with their famed sign. The first building behind them is named the Beaux-Arts, an attractive, innovate 1930 Art Deco apartment at 307 East 43rd Street.

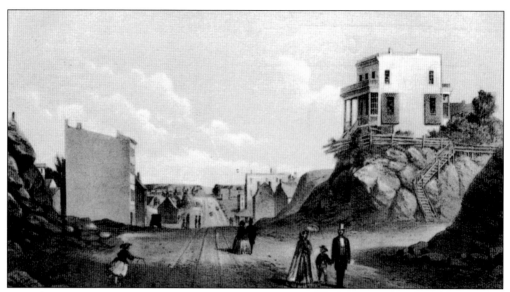

An 1861 print reproduced on a *c.* 1910 postcard shows how little settled the area north of 42nd Street had been. Even mid-19th-century home builders preferred high ground, but the occupants of the place at the right had quite a climb to claim a view.

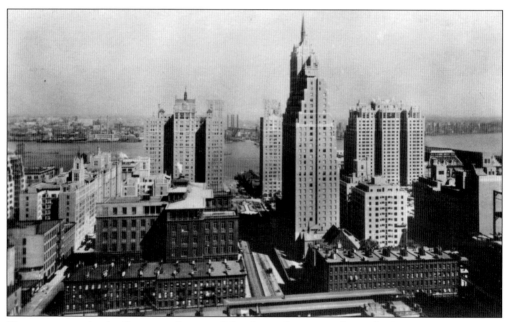

The tenements in the foreground, east of the Second Avenue Elevated, characterized much of this area. The 1942 demolition of the line facilitated development of the avenue (after World War II) and the surrounding side streets. Discernible behind the tenements are the hospital on page 127 (left) and the Presbyterian Church of the Covenant (right). The high rises are Tudor City, designed by H. Douglas Ives. The three largest residences appear in the background along a new street, then Prospect Place, later renamed Tudor City Place.

The 1956 completion of the Socony-Mobil Building at 150 East 42nd Street, the south side block from Lexington to Third Avenue, was a major post-World War II boost to 42nd's stature as a major office center. The move there of its namesake principal tenant was a blow to the city's downtown at a time when the area was on the verge of losing its standing as a major business district, Mobil having left its longtime home at 26 Broadway. The 42-story building, designed by Harrison & Abramovitz in association with John B. Peterkin, was the largest erected in New York since 1933 and at 1.3 million square feet, was the largest metal-clad (steel) office building and centrally air-conditioned commercial building in the world. Above its three-story base, clad in blue glass was an H-shaped structure rising to the 13th floor. The Automat in the foreground, at the southeast corner of Third Avenue, the last survivor of a once-thriving New York City institution, closed in 1991. The building was replaced by a glass office tower.

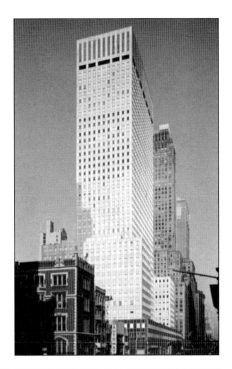

The Chrysler Building's surroundings are seen on two *c.* 1960s chrome views looking west. The Chrysler Building East, a 1952 work of Reinhard, Hofmeister, & Walquist, is under the tall tower. The 22-story, 1928 Bartholomew Building, designed by Starrett & Van Vleck, is next on the northeast corner of Third Avenue. Note the refacing the adjacent building received sometime between the years of the two views. At the far right is the 33-story, 1959 office by Emery Roth & Sons at 235 East 42nd Street.

Raymond Hood's News Building, completed in 1930 at 220 East 42nd Street, designed in conjunction with John Mead Howells, rises 476 feet on an L-shaped lot. A ten-story ell containing a printing plant, located on the Second Avenue side, is obscured by the 39-story tower in this view east. Hood claimed the building's design was dictated by utilitarian considerations, but it has a well-decorated Art Deco facade. The building rises in a series of monolithic slabs, its setbacks addressing constraints of the 1916 zoning regulation. The dark sections in this *c.* early-1930s photographic card are patterned by reddish-brown and black bricks in the horizontal spandrels. The newspaper's founder, Capt. Joseph M. Patterson, initially resisted a tower, but wound up with a good rent producer and a landmark structure. P.S. 27 is in the foreground, the site of the New York Helmsley Hotel, while the Second Avenue Elevated structure crosses the middle of the image, in front of Tudor City. (Courtesy of Charles Kleinman.)

The News Building globe is an extraordinary attraction in its four-story lobby, one that has fascinated crowds for generations. The 12-foot diameter, 4,000-pound sphere rotates slowly on an axis in a sunken well, lighted from below. The map was revised periodically but appears stuck now in the 1960s. A gigantic compass on the floor shows 58 principal cities and their relative distances from New York, while 17 panels on the black glass walls contain weather and meteorological information.

Tudor City included the 22-story Hotel Tudor at 304 East 42nd Street, "just two blocks east of Grand Central," containing 600 rooms, a bar, and a private cocktail lounge. Plans were filed in 1928 for a 57-story, 1,687-room apartment hotel, but it was never built. The hotel is pictured at the right, adjacent to the 34-floor Woodstock Tower, the tallest building in the complex. Although Tudor City, which spread from 40th to 43rd Streets, was contemporary with the major office construction in the Park and Madison Avenue areas, it preceded the major projects east of Grand Central. The prevailing architectural style was Tudor Revival, except for this hotel. Tudor City, New York's largest apartment colony, is now cooperatively owned and home to about 5,000 residents. The Hotel Tudor was remodeled in the 1990s and now operates as the Crowne Plaza at the United Nations.

HOTEL TUDOR • NEW YORK

A Glimpse of the Private Parks in Tudor City

Tudor City claimed to provide the charm of suburban atmosphere with midtown convenience. The city within a city was very densely populated, although only 7 of the 11 initially planned buildings went up. Economy of scale was important in controlling costs in Fred F. French's appeal to the frugal middle classes. However, Tudor City did provide open space through two parks and even a small 18-hole golf course. The parks were built on the west side of Tudor City Place, a street that was bridged over 42nd. One is pictured on a c. 1930s linen in front of the 12-story apartment, the Cloister, which marked Tudor City's northern border, while the 31-story Prospect Tower is at the right (p. 122). The still-appealing private parks, now maintained by Tudor Greens Inc., consist of paths, benches, and planting beds (happily eliminating the need to cut grass), along with a playground. The successful development was designated a New York City historic district in 1988.

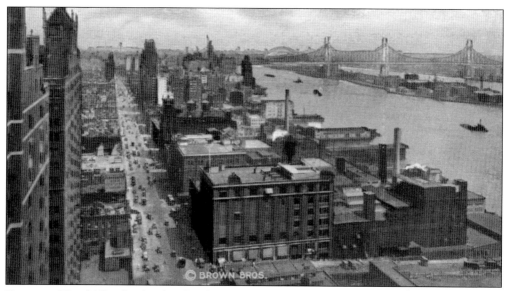

Known as Blood Alley for the slaughterhouses along the streets in the lower forties, First Avenue is pictured north from 42nd Street, *c.* the early 1930s. The meat-packing plants were obsolete by the end of World War II, and the owners willingly sold to William Zeckendorf, who envisioned development of a city within a city at the prime waterfront site. Zeckendorf chose architect Wallace K. Harrison, whose Rockefeller Center experience was a factor. However, the under-financed Zeckendorf was forced to sell.

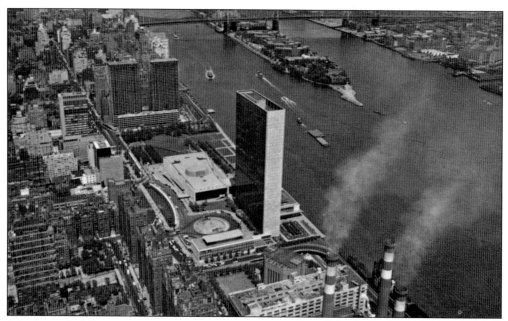

John D. Rockefeller Jr.'s purchase and donation of the $8.5 million First Avenue site assured that the United Nations would establish its permanent location in New York. Wallace K. Harrison was appointed chairman of a committee of architects with broad international representation for the 1947–1953 building project. In this *c.* 1965 chrome, Tudor City (bottom left) links this image to the card at top and to the pre-World War II period in an otherwise totally transformed landscape.

126

Committee member Le Corbusier objected to locating in New York to preclude the United Nation's presence in the shadow of the city's skyscrapers. However, the United Nations building best fixed in the collective public memory is its tall, 39-story, 544-foot-high Secretariat Building. The slender building, only 72 feet "thin," 287 feet wide, and containing 5,400 operable windows, was strongly influenced by Le Corbusier's work, but the famed French architect vigorously protested his perception of a lack of involvement in its construction. The Secretariat is an office; most of the United Nations's major work is performed in the General Assembly Building, visible in the picture on the bottom of page 126 and connected to the Secretariat's northwest corner. This photographic card dates from c. 1950.

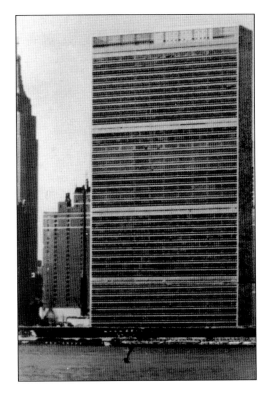

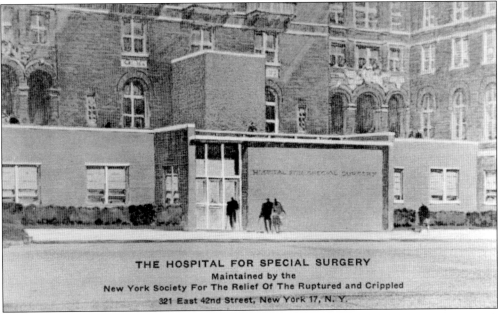

THE HOSPITAL FOR SPECIAL SURGERY
Maintained by the
New York Society For The Relief Of The Ruptured and Crippled
321 East 42nd Street, New York 17, N. Y.

The five-story Hospital for Ruptured and Crippled Children was built in 1911 on the north side of 42nd Street east of Second Avenue, designed by York & Sawyer. Named the Hospital for Special Surgery on this c. 1950 linen, the complex was later the Beth David Hospital, which sold the property to the Ford Foundation, which built its landmark headquarters on the site in 1967. (Courtesy of Joan Kay.)

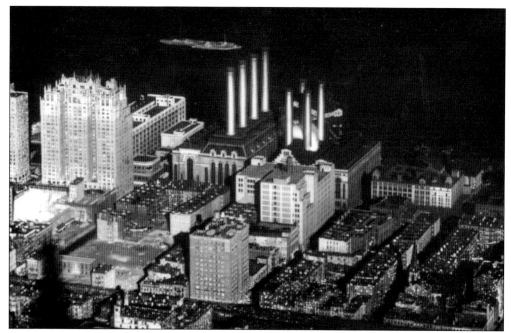

This aerial view shows the southern reach of Tudor City together with Consolidated Edison's near century-old Waterside Steam Plant. Development of that 9-acre parcel, currently up for sale, will likely be the largest midtown project for the foreseeable future. The plant has been altered since this 1930s image was printed on a John Kowalak card, as only three stacks now remain.

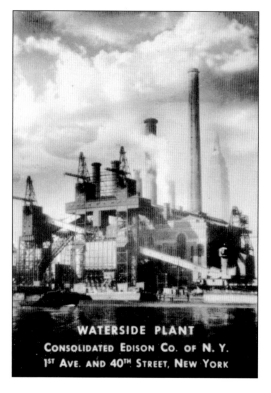

WATERSIDE PLANT
CONSOLIDATED EDISON CO. OF N. Y.
1ST AVE. AND 40TH STREET, NEW YORK

This photographic card was given to plant visitors to encourage others to come; it contained a printed message on the back, "I have just visited this plant . . . why don't you?" It is reminiscent of a time when industrial property was a lot easier to tour. Planning, environmental, and utility capacity issues will take some time to resolve, so the long-term fixture of stacks on the shore will likely not disappear overnight. Keeping the project compatible and harmonious with its Tudor City and United Nations neighbors is only one challenge. (Courtesy of Joan Kay.)